PENGUIN VEER

THE BATTLE OF REZANG LA

A product of the Naval Officers' Academy, Kulpreet Yadav has spent two decades as an officer in uniform and has successfully commanded three ships in his career. Since his retirement as Commandant from the Indian Coast Guard in 2014, he has authored several books in diverse genres, including espionage, true crime and romance. Winner of the Best Fiction Author Award for *Murder in Paharganj*, an espionage novel, at the Gurgaon Literary Festival in 2018, Kulpreet is also an actor and a film-maker. He lives with his family in Delhi.

THE
BATTLE OF
REZANG
LA

KULPREET YADAV

PENGUIN
VEER
An imprint of Penguin Random House

PENGUIN VEER

USA | Canada | UK | Ireland | Australia
New Zealand | India | South Africa | China

Penguin Veer is part of the Penguin Random House group of companies
whose addresses can be found at global.penguinrandomhouse.com

Published by Penguin Random House India Pvt. Ltd
4th Floor, Capital Tower 1, MG Road,
Gurugram 122 002, Haryana, India

First published in Penguin Veer by Penguin Random House India 2021

Copyright © Kulpreet Yadav 2021

This book is a work of non-fiction. The views and opinions expressed in the book
are those of the author only and do not reflect or represent the views and opinions
held by any other person. This book is based on a variety of sources, including
published materials and research conducted by the author, and on interviews and
interactions of the author with the persons mentioned in the manuscript. It reflects
the author's own understanding and conception of such materials and/or can be
verified by research. The objective of this book is not to hurt any sentiments or be
biased in favour of or against any particular person, political party, region, caste,
society, gender, creed, nation or religion.

ISBN 9780143452058

Typeset in Adobe Garamond Pro by Manipal Technologies Limited, Manipal
Printed at Thomson Press India Ltd, New Delhi

www.penguin.co.in

'You rarely come across such examples in the annals of world military history when braving such heavy odds, the men fought till the last bullet and the last man. Certainly, the Battle of Rezang La is such a shining example.'

—Gen. T.N. Raina, former Chief of Army Staff
(Gen. T.N. Raina was the Brigade Commander of the 114 Brigade under whose operational command 13 Kumaon's Charlie Company fought the battle of Rezang La in 1962.)

'The supreme sacrifice of the Charlie Company has fulfilled my expectations. I hope a suitable memorial will be built in Haryana so that the generations to come may seek inspiration from the immense courage and valour of their forefathers.'

—Gen. K.S. Thimayya, former Chief of Army Staff

'When Rezang La was later revisited, dead jawans were found in the trenches still holding on to their weapons . . . every single man of this company was found dead in his trench with several bullets or splinter wounds. The 2-inch mortar man died with a bomb still in his hand. The medical orderly had a syringe and bandage in his hands when the Chinese bullet hit him . . . Of the thousand mortar bombs with the defenders, all but seven had been fired and the rest were ready to be fired when the (mortar) section was overrun.'

—Maj. Gen. Ian Cardozo (Retd)

'When the Chinese attacked in an overwhelming number and death was writ all over, these gallant Ahirs stood their ground to the last man, last round, although they had an opportunity to move back and roll down the reverse slopes of the ridge and save their lives. Nay, they did not do so. They chose to hold their ground to the end, despite the fearful odds, defending their nation. Can anyone quote an example of such a high display of undying courage, devotion to duty and supreme sacrifice in any battle in the world? No, there is none.'

—Lt Gen. D.D. Saklani (Retd),
former Colonel of the Kumaon Regiment
(Lt Gen. D.D. Saklani, as a captain during the 1962 war, was the adjutant of the 13 Kumaon Battalion and was the last officer to speak to Maj. Shaitan Singh.)

'The gallant men of C Company of the battalion under the redoubtable company commander, Late Maj. Shaitan Singh, PVC, put up a fight at Rezang La, the like of which was never fought by any unit in the Indian Army in its entire history.'

—Brig. Raghunath V. Jatar (Retd)
(Brig. Raghunath V. Jatar was the post commander of B and D Companies of the 13 Kumaon Battalion on Maggar Hill located north of Rezang La.)

'I'm not aware of an equal in the annals of war.'

—Lt Gen. K. Bahadur Singh (Retd), former GOC-in-C,
Central Command, Indian Army

'The bravery, gallantry and patriotism displayed by Maj. Shaitan Singh and his C Company of 13 Kumaon was one of the most illustrious exceptions which redeemed the Indian Army's honour and created a legend for every soldier to emulate.'

—Lt Gen. R.R. Gaur (Retd),
former Director General of Infantry

*For every jawan on the border who lays down his life without
thinking about his family so that we can continue to be free*

Foreword

I've often wondered why we don't have more books and films featuring the heroic battles that our soldiers fought during the 1962 war with China. When I was invited to write a foreword for this book on the battle of Rezang La, I immediately accepted. I am delighted to see that the book lays a strong foundation of this epic battle that till now the nation has been deprived about knowing and discussing.

This story of the battle of Rezang La is the stuff legends are made of. 13 Kumaon, which is an all-Ahir battalion of Kumaon Regiment, fought valiantly, transforming a sure-shot debacle into one of the fiercest last stands in the history of the Indian Army, or for that matter, the entire world. The fact that just 120 infantry soldiers succeeded in stopping the largest standing army of the world is testimony to the courage, professionalism and commitment of these soldiers. They not only refused to move back even an inch, but when their ammunition got over, these brave soldiers jumped out of their trenches and went headlong into the enemy using their bare hands and bayonets. They were so highly motivated and

fearless that even the Chinese acknowledged their bravery and valour.

Three months after the war, when the mortal remains of these bravehearts including their company commander were found, it was seen that every one of them had taken bullets on their chest (not one was shot in the back). Brig. T.N. Raina had this to say about their bravery, 'You rarely come across such examples in the annals of military history, when braving such heavy odds, the men fought till the last bullet and the last man. Certainly, the battle of Rezang La is a shining example.' Indeed, the odds were heavily against these soldiers; they were hugely outnumbered, out-gunned and out-weathered, but each one of them fought like a true hero and proved to the world that determination, grit and belief are much bigger than any material odds.

The story of Rezang La needs to be told to all Indians, particularly the young generation who do not have access to any authentic and realistic story of this amazing saga of valour and courage. Everyone should know the cost that was paid to protect India in 1962. Today, we have not one but three memorials to honour and remember the soldiers who fought this epic battle. There's one near Rezang La itself, one in Rewari (Haryana) and another in Gurgaon (Haryana).

As someone who's always led from the front by setting a personal example, it's my great honour to write the foreword for a book that espouses the valour and bravery of the soldiers who defended our motherland in keeping with the highest traditions of the Indian Army. I, the only General officer in the world to have completed the Ironman Challenge, have always set my sights higher and pushed the limits of what the body and mind can achieve. In this epic battle, everyone, from the company

commander, Major Shaitan Singh, to the junior commissioned officers and the brave soldiers, exhibited exemplary mental and physical strength and single-minded love and devotion for the nation, which will inspire Indians for generations to come. Each one of the soldiers of the Charlie Company of 13 Kumaon, from the tall and well-built Lance Naik Singh Ram, who killed enemy soldiers with his bare hands, to Naik Gulab Singh, who jumped on the enemy's MMG, and Naik Ram Kumar, who didn't stop firing the 3-inch mortar even after getting hit by nine bullets and losing his nose to a shrapnel hit, had nerves of steel. I am sanguine that this book will not only remind everyone about the cost of freedom, but also inspire new generations to learn lessons from the bravery of these gallant heroes of the epic battle of Rezang La.

Jai Hind!

25 January 2021 Maj. Gen. Vikram Dev Dogra, AVSM

Preface

When I was in school, my brother and I, along with our parents, used to travel to Kosli, our ancestral village in Haryana, for summer vacations. It was a carefree period of my life and I have fond memories of those days, munching dhaani-bhugda (roasted barley and chickpeas), licking ice cream candy bars, eating rotis soaked in desi ghee, picking bers (Indian jujube fruit) from the wooded area that bordered our village, walking our buffalo to the pond, picking peacock feathers from the Arya Samaj ashram, playing hide and seek in the numerous havelis that belonged to our relatives and flying kites. Gulgalas, laadu (ladoos with whole peppercorns in them, can you believe it?), choorma and ghee-boora were the occasional treats. I know, many of you wouldn't have heard of these food items and I can't blame you for this of course, because I'm talking about the time when our respective sub-cultures were still intact.

One thing that was constant during these vacations was the mention of the battle of Rezang La, where, led by Maj. Shaitan Singh, the soldiers belonging to the Charlie Company of the 13 Kumaon Battalion had fought a valiant battle against the

Chinese. Almost everyone I knew, including my own family, had at least one close or distant relative, if not more, who had defended India and laid down his life in this battle. In those days, women used to sing *raginis* (folk songs) of valour—they still do—and everyone was proud of the war heroes of Rezang La. And yet, after returning from my vacation, year after year, as I mentioned this battle to my classmates in Kendriya Vidyalaya, Sec. 31, Chandigarh, where I studied, no one had heard of it.

Things didn't change after I joined Nowrosjee Wadia College in Pune. The students too had never heard of the battle of Rezang La. At that time, I thought this was okay. After all, India is a large country.

In 1991, I got into the naval officers academy and started to train to become an officer. I was looking forward to reading about famous Indian and world battles. But, here too, whenever I spoke to my instructors about Rezang La, no one had heard of this brave last-man-last-bullet stand of our soldiers. Subsequently, in all the units I served, on land or at sea, I didn't meet a single officer or jawan who had at least some idea about this battle. This disappointed me. But, by now, I understood the reasons for this lack of information. The debacle of 1962, where a Nehru-led India lost humiliatingly to China, was not allowed to be discussed in public discourses: books, debates, seminars or school lessons never talked about it. And therefore, not surprisingly, the story of the men who died fighting against all odds was simply brushed aside. After all, there were army generals to be protected, ministers to be kept away from public loathing and the image of a political establishment kept intact to the extent possible.

Finally, after serving for twenty-three years, I took voluntary retirement in 2014 from the Indian Coast Guard in the rank of

Commandant. Since then, I have written more than a dozen books on diverse genres that include espionage, romance and true crime. In 2018, when the thought occurred to me about writing a book on the Rezang La battle, it came to me as an epiphany, one that convinced me that all the preceding events of my life were a mere build-up for this moment.

I got down to writing a detailed proposal, which was approved by Penguin Random House India in just a few weeks. I was finally getting an opportunity to bring to life the truth about this battle. While I was aware that getting facts about this battle would be a struggle, the thought that was foremost in my mind at the time was that I would be burdening the survivors and the family members of those who had laid down their lives with the emotional pain of reliving their losses all over again. But, as I went about researching and writing this book, over the course of the next two years, more than the struggle, it led to a sense of fulfilment. It was as if an invisible power was egging me on and wherever I went, people, including relatives of the martyrs, met me with warm smiles, open arms and a sense of pride that filled my heart with a difficult-to-describe emotion.

Since not much has been written about this battle in the existing books and memoirs related to the 1962 war, my effort of reading dozens of books on this period bore little fruit. That's when I started searching for the survivors and I found two officers and four Junior Commissioned Officers (JCOs) who were directly related to this battle.

Brig. Raghunath V. Jatar (Retd) was in command of the Bravo and Delta Companies as a major at that time and was deployed on the hill adjacent to Rezang La called Maggar Hill. He had sent a patrol of four jawans during the battle to find out more details and lost two of them. Brig. Prem Kumar (Retd)

was a captain at that time and had led a platoon to Rezang La during end-October 1962 before he fell sick due to high altitude pulmonary oedema (HAPO) and had to be hospitalized in Srinagar, paving the way for Maj. Shaitan Singh to arrive at Rezang La with the remaining jawans of the Charlie Company.

Capt. (Honorary) Ram Chander (Retd) was holding the rank of Jemadar (this British-era rank was changed by the government to Naib Subedar after 1965) at that time and was the platoon commander of platoon 9 in the battlefield. Capt. (Honorary) Ram Chander (Retd) was a sepoy at that time and deployed right next to Maj. Shaitan Singh in the battleground as a radio operator. Havildar Nihal Singh (Retd) was a sepoy too and deployed in Company headquarters with an LMG (light machine gun) for the personal protection of Maj. Shaitan Singh. Havildar Gaje Singh (Retd) was also a sepoy and positioned with platoon 9. While I could speak to Brig. Raghunath V. Jatar (Retd) and Brig. Prem Kumar (Retd) over the phone, I drove down to meet the others at their villages in Haryana.

Talking to these officers and meeting these JCOs gave me a first-hand impression about the battle. Further, I was fortunate to meet many other officers, researchers and historians who had collated considerable information on the battle of Rezang La over the years. These include Maj. (Dr) T.C. Rao (Retd), Dr Ishwar Singh Yadav, Prof. K.C. Yadav, Rao Ajit Singh and Mr Naresh Chauhan.

Maj. T.C. Rao, an officer of the Kumaon Regiment and a successful businessman since his retirement, shared important information as he has been actively involved with the recognition of the Ahir valour. Dr Ishwar Singh Yadav shared four voluminous files with data and information related to the heroes of this battle that he had been collecting for decades.

Prof. K.C. Yadav, a historian and an accomplished author, was kind enough to share a diary which he had compiled in 2012, where many of the family members of the war heroes had provided personal details like letters and photographs. He also presented a book to me which was a compilation of various write-ups on the Rezang La battle. The most noteworthy among them was the detailed account written by Capt. Amarinder Singh (Retd), the present chief minister of Punjab, titled 'The Battle of Rezang La: A Blow-by-Blow Account of the Bloodiest Battle in the Indian Military History', reproduced from his book, *Lest We Forget*. And finally, Mr Naresh Chauhan, who heads the Rezang La Samiti that has done a lot of work for the widows and family members of the war heroes, shared information related to the martyred soldiers. In addition, I also travelled to various villages in Haryana and visited the family members of as many war heroes as I could.

One of the most authentic resources of this battle was the 'War Diary' of the 13 Kumaon Battalion and I was fortunate that, based on my request, the battalion formed a team and were able to unearth this hand-written, leather-bound book from the period 1960–70 in fairly good condition.

Writing this book has been an emotionally exhausting experience for me. This is the story of one officer and 120 jawans who fought a fierce battle to protect our nation on a very cold winter morning on 18 November 1962. Their weapons were outdated, they were short on ammunition, their clothing was ineffective against the cold and they had little food to eat. All they had was each other, an outstanding leader in Maj. Shaitan Singh, experienced tacticians in Naib Subedars Surja Ram, Ram Chander and Hari Ram, and a love for their motherland. And on that morning, it was enough.

Having written this narrative non-fiction account as objectively as I could, I finally feel relieved that the story of these unsung heroes is in the hands of the readers.

Jai Hind!

25 January 2020 Kulpreet Yadav
New Delhi Commandant (Retd)

1

29 September 1962, Baramulla, Jammu and Kashmir

The 13 Kumaon Battalion is ordered to move from Baramulla in Jammu and Kashmir to Leh. They are given only a few hours' notice. The commanding officer (CO) conducts a meeting with his officers and addresses the jawans just after receiving the order. Maj. Shaitan Singh, the company commander of the Charlie Company, addresses his jawans too and informs that he will be joining them a few days later as he has to hand over the quartermaster's charge. The Charlie Company will be led by Capt. Prem Kumar in his absence, he adds. Subsequently, Maj. Shaitan Singh also holds an operational briefing with the three platoon commanders of his company, Naib Subedar Surja Ram, Naib Subedar Hari Ram and Naib Subedar Ram Chander. The unit's convoy of vehicles commences its move by road after this.

At the battalion headquarters of 13 Kumaon in Baramulla, Lt Col H.S. Dhingra was staring at the decrypted message he had just received. The orders had finally come to move immediately to the border. As the CO of the battalion, Lt Col H.S. Dhingra

had the command of over 800 soldiers. The time was five in the evening and the pleasant temperature of around 15 degrees Celsius outside had started to dip.

The CO was known to be a hard taskmaster. He was a Sikh officer of medium height and build, but his most striking feature was his upturned, gravity-defying moustaches that stayed vertical at all times of the day. He glanced up at the radio operator who had brought this signal and after dismissing him with a nod, he reached out for the telephone. The radio operator briskly moved to the door, turned, gave him a crisp salute and shouted, '*Jai Hind*!'

13 Kumaon, like all battalions of the Indian Army, had four companies. These companies were commanded by officers of the rank of captain or major and comprised approximately 120 soldiers each. The remaining soldiers formed the staff of the battalion headquarters.

Lt Col H.S. Dhingra's call was picked up on the first ring by Capt. D.D. Saklani, the battalion adjutant. When the CO spoke, there was steel in his voice, 'We have to move to Leh within the next five hours. Prepare the orders and pass on the message. But first, I want the "O" group in ops room. On the double, in five minutes.'

The adjutant replied, 'Roger, sir!'

The CO placed the phone down and got up from his chair. He walked across to the window of his office and looked out. It was a typical autumn evening in Baramulla cantonment. He saw soldiers play volleyball while others cheered them from outside the court. As he watched, his mind elsewhere, the game got over and one team jumped with delight to celebrate their win.

The CO looked to his left and noticed smoke escaping from the *langar*. It was time. The cooks must be busy preparing

dinner for the troops. He looked further left and saw the vertical rope where three soldiers, apparently under punishment, were climbing the rope while a senior Non-Commissioned Officer (NCO) was waving a baton up and down animatedly. The CO could even hear the distant rumble of angry orders and reprimands. Not far away, further to the left, the unit washerman was removing clothes from the clothing line that he must have put out to dry when the sun was up.

This was an everyday sight but soon, the CO knew, everything was set to change. A shadow of concern crossed his face. He had no doubt about the capability of his battalion and the patriotism of his officers and jawans, but he was worried about the preparation time he had.

It took the CO just a few more seconds to firm up his mind. All he needed were three actions: move as quickly as possible, prepare defences on the border as best as possible, and fight with the true valour that the 13 Kumaon Battalion and the Ahir soldiers who comprised it were known for.

His thoughts turned to Srinagar where he had been admitted due to ill-health until last week and the faces of the officers of the medical board flashed before his eyes. When he had said that he wanted to join his unit and lead his battalion to the war in person, the doctors had warned him of serious medical consequences. But, as he insisted on going, they asked him to sign an undertaking that he was taking this risk knowing full well that he was not a hundred per cent fit. Lt Col H.S. Dhingra had signed the undertaking without any doubt and here he was.

Within minutes of his order to the adjutant, the CO heard the sound of the whistle. Every soldier knew, when blown this way by the Battalion Havildar Major (BHM), what the tone of the whistle meant. The regimental police were also going about

with the whistle to the extremities of the army base so that no corner of the battalion was left out.

There was a knock on the CO's door. The adjutant entered and gave a crisp salute, 'Sir, O group is ready in the ops room.'

The CO picked up his baton and marched out, the adjutant catching up behind him. The ops room was at the end of the corridor.

'Gentlemen, the war is imminent,' the CO announced, exchanging no greetings as he moved straight to the map in the ops room. He picked up the wooden pointer and started to explain. Besides the four company commanders, there was Maj. G.N. Sinha, the 2 I/C or the second-in-command, and the adjutant. All of them took out their small maps from the map cases they were carrying and started to make markings on them using china-graph pencils.

The CO pointed to the region of Ladakh and said, 'According to the ORBAT (order of battle), we will now be under the 114 Infantry Brigade. Besides us, there are four more battalions, 14 J&K Militia, 7 J&K Militia, 5 Jat and 1/8 Gorkha Rifles. The task allotted to the brigade is to protect this area, inflict maximum casualties on the enemy, and save as much equipment and stores as possible, if circumstances force us to withdraw.'

The CO paused and looked at each of those present for a few seconds and continued, 'We have only five hours' notice. Get your boys moving. The first halt will be at Leh so that everyone can acclimatize for the high altitude. Be prepared to stay put there for a few weeks, but if the situation deteriorates faster, we might have to take positions within days. Any questions?'

The officers shook their heads. Good officers never had questions and these were the best infantry officers of the Indian Army.

The CO's briefing lasted fifteen minutes and everyone moved back to their locations as soon as it got over.

Meanwhile, outside on the battalion's grounds, all four companies had assembled and were standing in a formation according to their identities. The companies were called 'Alpha', 'Bravo', 'Charlie' and 'Delta', or simply, A, B, C and D. The battalion headquarters' staff stood separately. The officers had arrived too and stood facing the soldiers. As soon as the minor shuffling of feet ended, there was pin-drop silence.

After the headcount, the adjutant made a report to the 2 I/C. Within seconds, the CO emerged from his office and walked towards the gathered officers and jawans of 13 Kumaon. The only sounds that one could hear were of his footsteps. The CO came to a halt bang in the centre facing the troops. There was no mic. It wasn't needed.

As the CO spoke, his deep voice boomed across the entire base, 'Patriots of 13 Kumaon, we have received the orders to move and the moment that all *fauzis* wait for has finally arrived. You must have heard on the radio about the tension on the border. Now, it's our turn to teach the Chinese a lesson. Are you ready?'

There was a roar, '*Ji sahab* (Yes sir).'

It was time for the battle cry now and on prompting, all the officers and jawans of 13 Kumaon shouted in chorus, '*Dada Kishan ki jai.*'

After a few seconds of silence, this was followed by, '*Bharat mata ki jai.*'

The CO's words and the shouting of the battle cry had sent a rush of adrenaline coursing through the veins of every soldier present. All looked straight ahead, faces chiselled after years of training in harsh conditions, now taut with determination. The battalion was raring to go.

As soon as the CO turned and walked back to his office, the company commanders stepped forward to face their respective companies. Among them was Maj. Shaitan Singh, the commander of the Charlie Company. Thirty-seven-year-old Maj. Shaitan Singh had just been promoted to the rank of Major. Besides being the company commander of the Charlie Company, he was also the quartermaster (QM) of 13 Kumaon.

He looked at the faces of the jawans and the JCOs of his company with pride. The Charlie Company had been the best company in sports and had some of the strongest and the fastest athletes in it. Most of the medals, both at the brigade level and even at the division level, were won by the Charlie Company.

One of their most recent achievements was winning the 'Best Defence Preparation' trophy at the division level in which all nine battalions had sent their best companies. The Charlie Company had represented 13 Kumaon and had returned as the overall winner.

The major started to speak, his voice calm and levelled, '*Samay aa gaya hai. Bharat mata ko hamare balidaan ki jarurat hai. Aur hum sab, hamesha ki tarah, ek jut hokar, Chinese ko muh tod jawab denge. Dikha denge ki jo Bharat mata ke anchal pe haath dalega, hum uska keval haath hi nahi, hum uska gala bhi kaat denge. Kya hum tayyar hain?* (The time has come. India needs our sacrifice. And all of us, like always, will face the Chinese with courage. We will show them that if they try to touch our Mother India with their hands, we will not only cut their hands, but we will also cut their throats. Are you ready?)'

The Charlie Company roared, '*Ji sahab.*'

'But today, I can't leave Baramulla with you, since I also have the charge of the quartermaster. Captain Prem Kumar

will lead you on my behalf. I will try to join as soon as I can, probably in a week.'

Maj. Shaitan Singh felt sad for having to say this but it was inescapable. As the quartermaster, he had the charge of the entire arms, ammunition and logistics under him which needed to be properly accounted for and then handed over to another officer. Although he had said one week, he was confident of wrapping it up earlier if he worked day and night.

'*Koi shhak* (Any doubts)?'

'*Nahi sahab* (No sir),' roared the company again.

He asked the platoon commanders to stay back and gave a *line-tod* command to the company. Within seconds, all jawans ran towards their barracks to collect their FSMO Scale A or the *bada pitthu*. The other companies were also ordered line-tod by their company commanders within seconds of each other.

Everyone could now see the three-tonne trucks that had started to line up simultaneously. The bada pitthu was already placed under their cots as per the standard procedure and therefore, all the jawans and JCOs needed to do, was change from the PT dress they were wearing, to the Angola shirt, brown woollen trousers and olive green (OG) jersey.

The major now spoke only to the three remaining platoon commanders who were all JCOs. '*Hamara op area aap ko pata hi hai* (You are already aware of our op area). It's cold and frozen. Here in Baramulla, as you know, we are at an altitude of 5300 feet above mean sea level. But Leh is at 11,500 feet. All companies will be deployed there so that our bodies can get acclimatized to the high altitude. After this, we will be deployed at the border which is around 18,000 feet. Once you reach the border post allocated to the Charlie Company, the first action

that I want you to complete is the job of "siting" of the LMGs (Light Machine Guns) and the mortars.'

Maj. Shaitan Singh now turned and started to move towards the Charlie Company's headquarters. The three platoon commanders began to walk alongside him as the major continued. 'I trust your experience. The siting of all our weapons is the most important action. Make sure the firing arcs are overlapping when you do the spit-locking of the trenches of the platoon and section positions. Also, we need to prepare the bunkers and trenches simultaneously.'

They were quiet for a few steps before Naib Subedar Surja Ram spoke, 'Bunkers? Are there no bunkers ready in our area?'

Five-feet-eight-inches tall and a good hockey and basketball player, Naib Subedar Surja Ram was the thirty-five-year-old JCO of the company, who had a total of nineteen years of service.

Maj. Shaitan Singh looked at Naib Subedar Surja Ram with a serious expression on his face and said, 'No, right now our border posts are few and far between, each with twenty men or more as part of our government's Forward Policy. These section-size and platoon-size posts are manned by police, CRPF and militia. As soon as our area is allocated to us, we will need three platoon posts for our 120 men, besides the company headquarters. So, lots of work is required to be done, Surja sahab.'

Surja smiled and said, 'Sir, the Charlie Company will do everything to make 13 Kumaon and our battalion proud. The Charlie Company was declared the winner in the defence preparation competition and we will work till the last ounce of energy in our bodies to prepare the best fighting positions.'

They reached the tent that acted as the ops room of the Charlie Company. Maj. Shaitan Singh was the first to duck

inside through the low flap door. The three JCOs followed him in.

Inside, there was a sand model of the Ladakh region. Maj. Shaitan Singh picked up the wooden pointer and began to brief them about the likely scenarios. Although the major didn't know the specific location where his company would be deployed, as that was yet to be decided by the brigade headquarters, he quickly ran over the general points that would be applicable to the whole area.

After the operational briefing, he inhaled deeply and said, 'The truth is, in all likelihood, this will be a fierce battle and there are likely to be casualties.'

The major paused for a few seconds, letting the weight of his words take its effect. The JCOs, however, looked at him impassively. At moments like these, all four experienced men knew assurances were not necessary. In the manner their eyes were locked, it was clear that the Charlie Company would live up to its reputation. Death was acceptable, but defeat was not. Naib Subedars Surja Ram, Hari Ram and Ram Chander saluted the major and left the tent. The briefing had lasted only ten minutes.

Two hours later, on the orders of the adjutant, all jawans ate a quick dinner at the langar. After this, they collected a bag of shakkar-paras and loaded their kit bags on the trucks. Then, all of them got down and lined up before the trucks for the puja ceremony.

By now, all the vehicles had been parked in a single line. The first vehicle was the official jeep belonging to the CO and the last vehicle was the recovery vehicle.

The battalion's pandit arrived with a thali that had all puja items on it. In the Indian Army, even performing a puja is a drill

and therefore, on the CO's nod, the laid-down procedure was initiated. A jawan placed two lemons under the tires of the CO's jeep in such a manner that the lemons would get crushed as soon as the vehicle moved.

The pandit then lit an agarbatti and placed it on the bonnet of the CO's jeep. This was followed by the chanting of mantras by the pandit. After two minutes, he stopped chanting, picked up the coconut from the thali and handed it over to the CO. The CO smashed the coconut on the road right before the jeep. The successful smashing prompted the shouting of the battle cry by all present, '*Dada Kishan ki jai.*'

Meanwhile, a jawan drained the coconut water in a glass and sprinkled it on the first few vehicles. Another jawan scooped out the white flesh of the coconut and gave it to the officers, JCOs and a few jawans who were standing in the front.

Then the CO and the driver sat in the jeep while the others waited. The driver turned the ignition and moved the vehicle just a couple of feet. The lemons were crushed and the vehicle's tyres and the hard surface underneath were smeared with lemon juice.

With the puja ceremony completed, by nine that night, the vehicles started to move and the long line of three-tonners and jeeps weaved their way through Baramulla town towards Leh along National Highway number 1. The sun had set almost two hours ago and in anticipation of a cold night, the road was almost deserted.

The officers and jawans seated in their vehicles felt bad leaving this wonderful town. 13 Kumaon had arrived from its peace posting in Ambala in the plains just three months ago and the affection of the local Kashmiris had won them over.

In one of the three-tonners sat a lance naik by the name of Singh Ram. One of the best boxers of the battalion, he was also

a wrestler and the main anchor for the tug-of-war competitions. He looked at Sepoy Ram Kumar, his real brother, who was seated right across, and smiled. Ram Kumar smiled back. Then Singh Ram turned his attention out of the truck. This is what he had been looking forward to—the real action.

There was a reason why the Kashmiris were fond of the Indian Army during the early 1960s. Right after Independence, on 22 October 1947, the Pakistani army had sent hundreds of pathans into Kashmir with orders to capture Srinagar. Although the pathans, known as lashkars, reached Muzaffarabad fairly quickly, once they arrived in this beautiful and historic town, they went berserk and started to indulge in indiscriminate raping and looting of the locals.

The 2000 tribesmen plundered the state armoury, set markets on fire and looted their goods. Then they shot anyone who couldn't recite the *kalima*—the Arabic-language Muslim declaration of faith. Most non-Muslim women were enslaved, while others jumped in the river to escape. The streets were littered with broken buildings, smashed furniture and charred bodies of the dead. The raiders spent three days in Muzaffarabad before sense prevailed and the leaders urged them to move towards Srinagar, the state capital 170 km towards the east.

When they reached Baramulla on 24 October 1947, they resumed looting, arson and rape. Initially, they targeted the Hindu and Sikh girls and women, raping and killing them, but later they didn't spare Muslim women as well. They looted, burned and vandalized shrines and temples too. Finally, they raped and killed Christian missionary nuns and nurses at St Joseph's Hospital. According to Tariq Ali, the author of

Kashmir: The Case for Freedom, the local cinema became a 'rape centre', with atrocities continuing for several days.

When the news of the attacks reached Srinagar, the maharaja called the Indian government and asked for help. The Indian government agreed after the maharaja signed the instrument of accession that made Kashmir a part of India on 26 October 1947. The Indian Army arrived on 27 October 1947 in Baramulla and saved the city by defeating the lashkars. Since the Indian Army had saved the lives of Kashmiris and restored their dignity, even in 1962, the locals had respect for it.

2

2 October 1962, Leh, Ladakh

The 13 Kumaon Battalion arrives in Leh and their acclimatization for the high-altitude area begins. The jawans are asked to rest, eat well and take it easy. Meanwhile, border skirmishes between Indian and Chinese forces have reached alarming proportions and the 114 Brigade's approximately 4000 men under the command of Brig. T.N. Raina headquartered in Leh are finding it difficult to secure the 400-km-long Ladakh border with China. One of the main reasons for the increase in tension on the border is the implementation of the Forward Policy in November 1961, under which dozens of small posts have been operationalized in the border areas. Finally, on 20 October 1962, China attacks the Indian forces all along the Sino–Indian border. In Ladakh, the Gorkhas deployed under Maj. Dhan Singh Thapa fight well but their posts called Srijap, located north of Pangong Tso Lake, and Yula, located south of Pangong Tso Lake are run over. The jawans of the Charlie Company are saddened by the Indian losses and begin working out in anticipation of their deployment on the border.

By the time 13 Kumaon's convoy arrived in Leh, it was midday and everyone was weary. Capt. Prem Kumar ordered the JCOs to assemble the company.

Once everyone had gathered in one place, Capt. Prem Kumar looked into their eyes and said, 'We are now in Leh, the largest city of the Ladakh region. This place is much colder as compared to Baramulla since it is a high-altitude area . . .' He paused for the information to sink in and then continued, 'I'm already aware that you have been briefed about this region in detail, but let me highlight the most important aspects once again.'

The jawans stared at their company commander without any expression or emotion as he resumed, 'The first problem you will face here in Ladakh is survival; fighting the enemy will come only after that. The boundary of the Ladakh region with China's Tibet is around 400 kilometres long. We have been guarding the nation's forwardmost posts all along this border from Karakoram Pass in the north to Demchok in the south. Any questions so far?'

'No, sir.' There was a chorus.

'*Bahut achhe* (Very good)! Ladakh is a cold desert. Our convoy crossed most of the 420-kilometre distance during the night; otherwise you would have noticed that the last of the jungles are till Sonmarg, that is just 80 kilometres east of Srinagar. After that, the tree density starts to thin down. Since breaking of dawn this morning, the difference between the Kashmir valley and Ladakh must have become evident to you. Though Ladakh has its own beauty and it's a holy place inhabited by warm and kind people, you will take some time to get used to this barren sight. Now, who can tell me the altitude of Leh?'

Many jawans raised their hands. The JCOs, who were seated right in front, turned and arched their backs to see if

their respective platoon's jawans had raised their hands. Though belonging to the same company, there was always a constant but healthy competition between the platoons.

The captain pointed at one of the jawans, 'Yes, you tell us.'

The jawan answered, 'Sir, 11,500 feet.'

'Very good. Sit down. So, we are indeed in a high-altitude area right now. But we will be deployed at the border with China that's even higher. Can someone tell me at what altitude the army's high-altitude area begins?'

Again, several jawans raised their hands and the captain pointed at one of them.

'Sir, above 9000 feet is high-altitude area where we get special rations including brandy for medical use, but after 15,000 feet, it becomes super high altitude.'

Everyone laughed at the mention of special rations and brandy.

'Right, now listen carefully, due to the lack of oxygen in Leh, any kind of exertion is banned for the next one week till your bodies get acclimatized.' Capt. Prem Kumar smiled for the first time and in his concluding remarks, said, '*Aapko yahan keval do hi cheez allowed hain, aur woh hain, khana aur sona* (You are allowed only two things here, and they are eating and sleeping).'

The jawans laughed again and broke off on command.

The company commanders of Alpha, Bravo and Delta companies also briefed their jawans along the same lines. This was perhaps the best time for the jawans of 13 Kumaon to write letters home and inform their loved ones about their well-being. After an intensive, twelve-hour training every day for the past three months in Baramulla, Leh was a welcome break.

The defence of Ladakh in early October 1962 was the responsibility of the 114 Brigade under the command of

Brig. T.N. Raina headquartered in Leh. There were four battalions under his command with a total of around 4000 men, stretched across the 400 km of Sino-Indian frontier. These battalions were 14 J&K Militia, 7 J&K Militia, 5 Jat and 1/8 Gorkha Rifles. In addition, there was a platoon (MMGs) of 1 Mahar with 1/8 Gorkha Rifles.

In October 1962, the road infrastructure in Ladakh was poor as there was only one road that connected Srinagar to Leh. All other land communications were through mule tracks and therefore, the entire supply of stores to forward Indian posts was maintained through air sorties. The only all-weather airport was in Leh. The airstrips at other locations were designated as the Advanced Landing Grounds (ALGs) that could only be operated at certain times of the day and required a high level of maintenance after every air operation. These ALGs were located in Chushul, Daulat Beg Oldi, Thoise and Fukche. The Dropping Zones (DZ) had a different set of challenges. Since the DZs needed to be planned in flattened terrains and the forward posts had to be close to them, the border posts were often deployed in tactically disadvantaged positions. The Chinese, who were more in number and had well-connected posts with roads reaching their base establishments in the deep, often seized Indian supplies.

By now, the entire nation was convinced that India and China would go to war. Even though Prime Minister Jawaharlal Nehru had said in the Parliament, as All India Radio had reported, that the few instances of attacks by the Chinese and the counter-attacks by the Indians on the border posts were localized incidents and would not lead to war, the mood of the nation was different.

In the coming days, the 120 jawans of the Charlie Company restricted themselves to just three things: maintaining .303 Lee Enfield bolt-action rifles and other weapons, sharing stories and jokes with one another, and writing letters home. Another topic that was common in almost all the conversations was about the latest films. *Ganga Jumna*, starring Dilip Kumar and Vyjayanthimala, was a favourite. But this was not the only one. Many jawans also talked about *Junglee*, starring Shammi Kapoor and Saira Banu, and *Hum Dono* that had Dev Anand in a double role, in both roles as an army officer. There were many battle sequences in *Hum Dono* and these scenes were a matter of much debate and discussion among the jawans.

Meanwhile, on 10 October 1962, in the eastern part of the country, an Indian Army patrol of fifty troops at Yumtso La in North-East Frontier Agency (NEFA) encountered 1000 Chinese soldiers. This was a dangerous face-to-face confrontation and clearly one-sided. Tragically, there was no artillery support available for the Indian patrol. Both sides held their fire for some time but finally, the Chinese opened fire on the Indian troops and a gun battle ensued. The Indians fought back, inflicting heavy casualties on the Chinese. At this point, the Chinese started to fire with mortars. As the Chinese were regrouping and the Indian patrol's commander was able to contact Brigadier John Dalvi, their brigade commander, he was ordered to retreat. This, the brigadier justified later, was the best course of action given the hopeless situation for the Indian jawans. The Chinese stopped firing as they watched the Indians retreat and in fact, they buried the Indian soldiers with full military honours in front of the retreating soldiers' eyes. The Indians lost twenty-five soldiers on that day while the Chinese lost thirty-three. Although the situation had been

defused, it acted as a catalyst for both the nations to fast-track their war preparedness.

Also, in October 1962, 350 Chinese troops had surrounded the Indian post at Srijap, located on the north shore of the Pangong Tso Lake in Ladakh, and used loudspeakers to influence the 1/8 Gorkha Rifles that was deployed there that, being Gorkhas, they should not be fighting for India. After intimidating the Indians, they finally withdrew.

The jawans had only two sources of information regarding what was happening. One was through Capt. Prem Kumar, who was their company commander in the absence of Maj. Shaitan Singh, and the second was through the All India Radio news bulletins. There were rumours as well and though the jawans listened to them, they paid no attention as they were trained to ignore rumours. It was due to incidents like these that all four companies of 13 Kumaon were ordered to move in small batches from Leh towards the Chushul airstrip.

There was another reason that had prompted the government to step up the defence preparations in Ladakh. Based on the decision of the Forward Policy that was taken in a meeting in the prime minister's office during November 1961, thirty-six new posts had been established all along the Ladakh border by October 1962. Since these posts were small, often just section-size or platoon-size, as we have seen Maj. Shaitan Singh discussing this with his three JCOs in Chapter 1, they were often encircled by the Chinese and harassed. The Chinese did this because they thought that the Indians were trying to forcibly occupy the areas that they considered their own. Due to a diplomatic and a political stalemate with China at the top, the Indian Army, which had seen no expansion since independence from Britain in 1947 and considered a burden on the exchequer

in a politically-perceived non-aligned future of the world, was gripped by tussles between senior officers in Delhi. In October 1962, no one had any idea that the nation was just days away from paying a heavy price.

20 October 1962, Ladakh

The war with China that the prime minister of India was convinced would never take place, however, started on 20 October 1962 as China's People's Liberation Army (PLA) launched a simultaneous and well-planned attack on the forward Indian posts in NEFA and Ladakh. Within four days, the PLA had captured all the Indian posts it considered as Chinese.

The Indian Army was ill-prepared for this massive attack due to various reasons. Disadvantaged by a ratio of 10:1 in terms of manpower, broadly, these reasons included outdated guns with the Indian jawans, insufficient ammunition, absence of roads, poor intelligence and even a lack of snow clothing and availability of basic stores.

For the purpose of this book, let's restrict ourselves to the Chushul area only. During this period, the Indian forward posts located in the Chushul sector came under the Chinese attack too. Three posts, called Srijap, Srijap 1 and Srijap 2, all located in proximity to one another, were overwhelmed. The Gorkhas fought valiantly, but they were just a few dozen as compared to the Chinese who were in their hundreds.

In Srijap, Maj. Dhan Singh Thapa was in command of the Delta Company of 1/8 Gorkha Rifles. The Delta Company was stretched thin as it had only twenty-eight jawans present at the time. Another key problem was the fact that since the post was

located on the northern shore of the Pangong Tso Lake, there was no road link with its headquarters in Chushul and all the logistics were supplied by boats.

When the attack came at 0430 hours on 20 October 1962 in the form of a heavy artillery attack, the brave Gorkhas took shelter in their well-prepared bunkers. Thereafter, under the cover of artillery attack, as the Chinese infantry troops reached as close as 150 yards from the Indians, the company opened fire using LMGs and rifles. The first Chinese attack was defeated. Similarly, two more attacks were defeated by the Gorkhas. But by now, the brigade headquarters had lost communication with the company due to intense bombing and therefore dispatched the two storm boats belonging to the army to check the status of the Delta Company. When the boats were halfway across the lake, they were fired upon by the Chinese. While one boat sank and its crew died, the second boat was successful in coming back. The sepoy who was present in this boat confirmed the brigade's worst fears that the Indian post had been annihilated and everyone, including Maj. Dhan Singh Thapa, had been martyred. Later, however, the Indian government would realize that the company commander was alive and, in fact, had been taken prisoner by the Chinese along with two more jawans.

Similar to Srijap, on the southern edge of the Pangong Tso Lake, there were three posts collectively called the Yula complex. These were manned by another company of 1/8 Gorkha Rifles, while the other two companies of the battalion held the Spanggur Gap, Gurung Hill and Maggar Hill. After the Chinese bombarded them heavily, all these posts were initially consolidated in one location for tactical reasons and subsequently withdrawn.

The jawans of 13 Kumaon received the news of the martyrdom of the Gorkhas in trickles. This was a sad blow for them and they were stunned into silence. Unable to do anything for their fellow soldiers, all they could do was join their hands and pray. But, as their emotions stabilized, the jawans felt more clear-headed. By now, they had been acclimatized to the altitude of Leh and therefore, after taking permission from the JCOs, the jawans started their physical exercises to sweat out their pent-up anger and frustration. Lance Naik Singh Ram, assisted by his brother, Sepoy Ram Kumar and others, organized group competitions too.

Before the 1962 war with India, the Chinese had infiltrated all walks of Indian life and had sources at the right places to gather operational intelligence. Claude Arpi, the author of *1962 and the McMahon Line Saga*, writes how the Indian secrets could have been compromised: 'Some war veterans recall that on the way to Bomdila (in NEFA), there was a dhaba manned by two beautiful 'local' girls. All officers and jawans would stop there, have a chai and chat with the girls. It turned out later that they were from the other side. An informant tells me that when Lt Gen. B.M. Kaul was evacuated from the Namka Chu on 8 October 1962, having fallen sick due to the altitude, he was carried pick-a-back by 'local' porters. It was later discovered that one of them was a Chinese interpreter in a PoW camp in Tibet. The secrets were out!'

3

24 October 1962, Chushul, Ladakh, Jammu and Kashmir

After 24 October 1962, Chinese forces halt their attacks. The advance party of the Charlie Company leaves by road for Rezang La under the leadership of Capt. Prem Kumar. This is a platoon-size deployment. The jawans of the Charlie Company don't have proper clothing for the cold at this altitude and the cooks are unable to prepare food. The next morning, Capt. Prem Kumar and Naib Subedar Surja Ram conduct a reconnaissance and decide on the locations of the three platoons and the company headquarters. But soon, Capt. Prem Kumar begins to show signs of high-altitude pulmonary oedema (HAPO) and is evacuated. Maj. Shaitan Singh arrives thereafter with the remaining jawans of the Charlie Company. He fine-tunes the already prepared plan and digging starts immediately.

The war between India and China was continuing both in NEFA and in Ladakh. Although the Indian Air Force

and the Indian Navy had not been used so far, the armies of the two nations were engaged in a border conflict since 20 October 1962.

Like all other jawans in Leh, the jawans of the Charlie Company too were disturbed by news of the Indian losses all along the border. By now, Namka Chu River in NEFA had already been lost and the entire 7 Infantry Brigade comprising over 2000 jawans and around two dozen officers had been annihilated and Brig. John Dalvi, the brigade commander, had been taken prisoner.

Since receiving the orders to move to Chushul from Leh, Lt Col H.S. Dhingra was busy with his team in planning an organized movement of all the four companies of 13 Kumaon. The CO had already been to Chushul for a reconnaissance with the brigade commander once and was therefore aware of the situation on ground.

The first convoy (advance party) of 13 Kumaon left Leh for Chushul at 0430 hours on 24 October 1962. This was a small batch and it was planned that in similar small batches, everyone would be moved as soon as possible.

In the vehicles navigating the unmetalled jeep track from Leh to Chushul, which was carrying the advance party, the mood was somber. The jawans had a lot of questions by now. But they were too well-trained to bring them to their lips. One hundred per cent devoted and patriotic, they were awaiting their chance to reach the border and fight the Chinese—fight with all their might. Because death was acceptable, but defeat was not.

In the front section of one of the trucks sat Naib Subedar Surja Ram and Company Quarter Master Havildar (CQMH) Jai Narain.

They had been quiet for a while when Naib Subedar Surja Ram spoke, 'I feel sad for our Gorkha brothers of 1/8 GR. They fought like lions.'

CQMH Jai Narain took a deep breath and replied, 'Salute to Major Dhan Singh Thapa sahab.'

'And the company senior JCO, Subedar Min Bahadur Gurung.'

'Yes, and to all the brave Gorkha jawans.'

Then, Naib Subedar Surja Ram added, as if talking to himself, 'All we need is artillery support and timely reinforcements. If we get these, our boys will tear the enemy into pieces.'

'I think the Gorkhas could not be helped with reinforcements because they were across the lake. We are being sent to Rezang La which can easily be supplied with everything we need from the rear.'

'Right . . .' After a pause, he continued, 'Sadly, the news from NEFA and other posts in Aksai Chin is also not good.'

The CQMH nodded thoughtfully.

Similar feelings were going on in the minds of the jawans who were seated in the back. Though there was a studied silence at most times, the jawans occasionally broke into random chats. Everyone was sad at the developments all along the border and they certainly were a bit anxious, but they were unafraid. In fact, most of them wanted to reach their trenches, or the *morchas* as they called them, and wait for the Chinese to get close. As they travelled towards their destination, they also gorged on their personal stock of Gondh ke laddu, the traditional high-energy snack they brought back with them whenever they went on leave.

After a bumpy sixteen-hour ride, the convoy finally stopped on the Tsaka La road around 20 km south-east of the Chushul airfield.

The first batch of jawans of the Charlie Company of 13 Kumaon disembarked from their trucks. As they stood in a formation for a headcount, Capt. Prem Kumar informed them of their exact post on the border.

He spoke loudly so that everyone could hear him, '*Charlie Company ke bahaduron, hum apni manzil tak pahunch gaye hain. Woh dekho* (The brave soldiers of the Charlie Company, we have reached our destination. Look there) . . .' He pointed to his right at the mountains which seemed to have an opening and continued, '*Woh hai Rezang La. La ka matlab, jaisa aapko pata hi hai, hota hai, pass. Rezang La ek mountain pass hai. Uske doosri taraf do lake hai. Badi wali north mein hai jiska naam hai* (That, over there, is Rezang La. As you already know, La means a mountain pass. Therefore, Rezang La is a mountain pass. On the other side are two lakes. The one on the north is called) . . .?'

The seniors knew, but they kept quiet so that the sepoys could answer. Many raised their hands. The captain pointed at one of them and he said, 'Pangong Tso.'

'Very good. *Tso ka kya matlab hota hai* (What does Tso mean)?'

'Sir, *Ladakhi language mein tso lake ko bolte hain* (Sir, in Ladakhi language, Tso means a lake).'

'Very good. *Ab doosri lake ka naam kaun bataega* (Now, who will tell me the name of the second lake)?'

This time the captain nodded at another jawan.

'Sir, Spanggur Tso.'

'Very good. *Shabaash! Ab aapko pata hi hai ki Pangong Tso bahut badi lake hai, aadhi hamare paas hai aur aadhi China ke paas. Lekin Spanggur Tso chhoti lake hai. Abhi hum location pe jayenge aur apne morchhe tayyar karenge. Hamare pass keval teen ghante ki roshni baaki hai* (Excellent. As you know, Pangong

Tso is a very big lake, half of which is with India and half with China. But Spanggur Tso is a small lake. Now, we will start moving to our location, and we will prepare our defensive positions. We just have three hours of daylight remaining). Let's go!'

The area south of Pangong Tso Lake had not been attacked by the Chinese so far. Therefore, everyone present on that day was aware of the impending attack and understood that they had to move quickly. The troops started to organize themselves, while Capt. Prem Kumar went to the adjoining area for a quick visual reconnaissance. By the time he was back fifteen minutes later, everyone was ready. On his command, they started to move on foot towards Rezang La Pass. The temperature was around 8 degrees Celsius. The jawans had their bada pitthu and their 'first line of ammunition' in their pouches besides their .303 rifles, a total weight of around 40 kg.

Capt. Prem Kumar looked at CQMH Jai Narain and said, 'I think this is the best place for us to set up the admin base of the Charlie Company.'

CQMH Jai Narain looked around as if trying to find a proper spot before his eyes froze at a point and said, 'Yes, sir. I think we do have a decent spot.'

'Great! I'll leave you here with two jawans. You start your action and meet me tomorrow morning at the pass.'

'Roger, sir.'

With that, Capt. Prem Kumar started to lead the platoon-size batch of the Charlie Company with two radio operators, Sep. Ram Chander and Sep. Mohinder Singh walking alongside him. Sep. Ram Chander was carrying the wireless set no. 88, a lightweight battery-operated man pack VHF-FM radio set with a range of approximately 2 miles. It was an ideal set for

communications between platoons and company headquarters. Sep. Mohinder Singh was carrying the wireless set no. 31 for communication between company headquarters and battalion headquarters. Bulkier than wireless set no. 88, the range of set 31 was from 3–5 miles and it weighed around 17 kg as compared to 5 kg of set no. 88. Walking beside them was Sep. Nihal Singh who was carrying an LMG as he was tasked with the duty of personal safety of the company commander. The company commander, on the other hand, was carrying a 9 mm pistol.

It turned out to be an arduous climb. The jawans were out of breath after every few steps and had to stop to feel better. Despite the acclimatization in Leh, even the toughest of the jawans were finding it difficult to move due to the rarified mountain air. Being above the tree line, the entire region around them was dry and without vegetation and as sunset approached, the temperature started to plummet. The shivering troops, who were not even in their winter clothing, let alone high-altitude snow clothing, had to use every ounce of energy in their bodies to push themselves forward.

One of the main challenges was to transport the 3 LMGs and one 2-inch mortar that they were carrying. The balance of the company weapons which included six LMGs, three 2-inch mortars and two 3-inch mortars were to be brought a few days later with the remaining troops and Maj. Shaitan Singh.

As one set of soldiers got tired of carrying these heavy weapons, they passed them to the others and this went on in rotation. The jawans were also tasked to carry the spool on which the telephone cable had been rolled, and as they climbed, the wires were laid out for physical line communication.

Capt. Prem Kumar was right in front. A young and energetic officer who had got married a few months earlier, he

was encouraging everyone and moving faster than the others to set a personal example. 'Come on, brave soldiers, only a little more distance is remaining . . . very good . . . yes, that's the way.'

In all, it took them close to three hours to cover the distance of around 4 km. It was dark by then. There were troops from CRPF already deployed at that post and they were waiting for the C Company to arrive. These CRPF troops were only happy to hand over the post of this inhospitable terrain to the Indian Army and leave.

The bunker that the CRPF had prepared and were using at that time was right in the middle of the Rezang La Pass. This bunker could, at best, accommodate ten jawans. But the C Company's advance party had forty jawans. These also included two cooks, one barber and one Equipment and Boot Repairer (EBR).

Cooking was out of the question that night as everyone understood that the cooks needed time to establish a langar. Therefore, that night they ate shakkar-paras, drank water and slept in the open, wearing their summer uniforms and jerseys, balaclavas on their heads, and the final layer being of the blankets that they had removed from their bada pitthus. But this was insufficient for the cold at that location and soon the jawans started to shiver uncontrollably as the temperature dropped further. By midnight, it was minus five degrees Celsius.

Early next morning, as soon as the sun came out, the troops started with their action. The first was, as Maj. Shaitan Singh had ordered, to position the platoons tactically. Since only one JCO, i.e., Naib Subedar Surja Ram had arrived with the platoon, he walked across to Capt. Prem Kumar and greeted him, '*Ram Ram sahab.*'

Capt. Prem Kumar coughed and replied, '*Ram Ram*! How was the night?'

'Not very bad, sahab. How are you feeling?'

Capt. Prem Kumar didn't reply immediately. After a few seconds, he took a deep breath and said, 'I'm fine.'

Naib Subedar Surja Ram nodded and looked around.

Capt. Prem Kumar started speaking again, 'Okay, so let's get on with our preparations. As you know, our orders are to block the Rezang La Pass and deny access to the Chinese. The pass is around 2000 yards wide and 3000 yards long. That's a fairly large area for a company to hold. We have seen it on the sand model and maps so many times, but practical is always different than theory. Therefore, let's do reconnaissance first.'

The captain turned towards CQMH Jai Narain who had just arrived, and said, 'Send a message to the battalion headquarters that we need high-altitude clothes and rations by the end of the day today. And they should send the Pioneers with the right tools and dynamite sticks to make bunkers. The surface is frozen solid. I'm not sure how much we will be able to achieve with the tools that we have.'

'Roger, sir.'

With that the captain and Naib Subedar Surja Ram started to walk. They covered the entire length and breadth of the area on foot, identifying the features on the map and relating to them on the ground. But every fifty metres, Capt. Prem Kumar would pause for a few minutes before resuming. Once, Naib Subedar Surja Ram said, 'Sahab, if you are feeling unwell, you could just wait here and let me do the recce and come back with a detailed report for you.'

'No, I'm fine.' Capt. Prem Kumar was on his feet and started to move.

After this, the JCO didn't comment any further and just adjusted his speed according to the condition of his commander. Clearly, Capt. Prem Kumar was getting sick with every passing minute. Naib Subedar Surja Ram had only one worry: What if captain sahab was suffering from high-altitude pulmonary oedema or HAPO? If this was true, his condition would deteriorate rapidly. He only wished the captain held out until Maj. Shaitan Singh arrived.

Consequently, covering the entire area was a painstaking process and required skill, patience and endurance. In the end, the effort yielded positive results. They had spotted the highest point in the area called point 18300 right ahead of them and keeping that as a reference, they had identified the ridges, spurs, gullies, folds, hills and valleys in the whole area.

It is befitting here to reproduce how Capt. Amarinder Singh had described the area of Rezang La in his book *Lest We Forget*:

'At 14,400 feet, the Spanggur Tso is the lowest feature in terms of altitude in this region. From it, start shallow hills, in the shape of folds, then rise within the vast plain to form bigger hills and mountain ranges. These hills are quite bare, with outcrops of rocks on the slopes and the gullies. The tops are usually quite flat with no trees or flora of any kind. Ladakh, being in the rain shadow area, has very small rainfall each year, the few inches of precipitation that occurs is in the winter months and then principally in the form of snow. The whole area resembles a desolate moonscape.'

After a lot of discussions and due to the fact that the JCO's experience was more than the captain's, the captain approved the plan proposed by the JCO.

A few seconds later though, he remarked, 'Surja sahab, the plan is good, but the final decision will be taken by Major Shaitan Singh when he arrives.'

'Yes, sir.'

'From what I can appreciate, I'm confident that Major sahab will approve this plan.' After a few deep breaths, he continued, 'Our bunker for platoon 8 is ready. Let's start making bunkers for platoon 7 and 9 right away and alongside them, deploy your men to start digging the trenches as well. The construction of bunkers for platoon headquarters and trenches for section posts should go on side by side.'

'Roger, sir.'

On completion of the decision regarding various locations, Capt. Prem Kumar and Naib Subedar Surja Ram marked their maps as per ground positions, placed them back into their map cases and returned to where everyone was. They saw that the cook was trying to bring water to a boil.

Capt. Prem Kumar asked him, 'How long will it take for you to prepare tea?'

The cook frowned and said, 'Sir, the ice has melted. But the water has been on the stove for the last two hours and has not yet come to a boil.'

Capt. Prem Kumar knew this, 'In this cold, you can't boil anything with just a stove. What we need is a pressure cooker.'

He looked at the CQMH who said, 'Sir, your last message has already been conveyed.'

The captain nodded and said, 'Send another one. We need pressure cookers and tinned provisions immediately. Ask the cooks what else they need. Make a list and send it.'

With that, Capt. Prem Kumar had a bout of coughing and he sat down heavily in a camp chair. There was pink spittle hanging from the edge of his lips. Naib Subedar Surja Ram knew what this meant and signalled for Sepoy (Medical Assistant) Dharampal Dahiya to examine him.

Sepoy Dahiya confirmed Naib Subedar Surja Ram's worst fear. 'Captain sahab is suffering from high-altitude pulmonary oedema. The only way we can save his life is by evacuating him to a hospital that's located at a lower altitude.'

By midday that day, there was good news waiting for the platoon. Their kit bags had arrived on yaks and ponies shepherded by local Ladakhis from Chushul. These locals were on the army's payment rolls and also acted as intelligence sources.

The sight of yaks and ponies brought a smile to the jawans' faces and as soon as they identified their personal kit bags, they ransacked them, took out whatever clothes they could find and wore them one on top of the other to fight the cold. Now they had their personal bedding to sleep in too. It was a big relief.

Naib Subedar Surja Ram had meanwhile informed the battalion headquarters about Capt. Prem Kumar's medical emergency and therefore, along with the yaks, a medical assistant had also arrived. Capt. Prem Kumar was only semi-conscious by now and he was seen off by Naib Subedar Surja Ram, though with a heavy heart.

After the captain had left, the command of the platoon automatically rested with the Naib Subedar who was the senior-most soldier present at the post.

But there were more problems waiting for Naib Subedar Surja Ram. Within the next few hours, nearly one-fourth of the troops had started to show symptoms of high-altitude sickness.

Not that this was unexpected, given the fact that the troops had arrived just last night from Leh to Rezang La and the altitude difference was over 6000 feet. But currently, what they were suffering from was the mildest of the three stages in mountain sickness. Although the troops were experiencing muscle pain, nausea, and it felt like a bad hangover, this stage could easily be tackled by taking medicines and a lot of rest. While the former was easy, the latter was something that they just could not afford.

The nation was already at war and here they were, unprepared on a frigid, rocky surface with no protection, ill-equipped, ill-armed, underfed, inappropriately-clothed and ill-prepared. The only thing they had on their side was their fitness and their patriotism. Now, even their fitness was under threat, so all they had was the love for their nation.

Naib Subedar Surja Ram called for Sepoy Dharampal Dahiya. As soon as the cheerful-looking Dahiya arrived, Surja said, 'How many medicines do we have for mountain sickness?'

'Sir, not much, as our medical supplies are yet to arrive. I have a few tablets and I have given them to the serious cases.'

'By now, more troops must have arrived at the spot where we had got down yesterday. You go down and get more medicines.' Then Surja turned towards the radio operator and said, 'Ram Chander, I want you to go too and connect our telephone lines to the base below.'

The time now was 3 o'clock in the afternoon. That day, Surja Ram decided to give his jawans some rest to acclimatize to this new altitude. There was a war going on and they could not afford casualties before they even got a chance to fire a bullet.

The nursing assistant and the radio operator left immediately. By late evening, they were back with the medicines and the jawans who were feeling unwell took them and slept.

The rest did them good. The next morning, the jawans were feeling more at ease. Sleeping under additional layers of blankets that had arrived in their kit bags the previous day and wearing personal warm clothing underneath their Angola shirts and jerseys allowed them to sleep better. The temperature during the night was minus ten degrees Celsius but they knew it was expected to touch minus thirty in the coming weeks if not days.

A little before noon, the radio operator received the message that Maj. Shaitan Singh was on his way to Rezang La with the rest of the Charlie Company and the arms and ammunition. A wave of excitement ran through the platoon.

Born on 1 December 1924, Maj. Shaitan Singh, at the time of India's Independence, was a part of the Jodhpur state forces. Once the Jodhpur state acceded to the Indian union on 7 April 1949, he was transferred to the Indian Army's Kumaon Regiment. An experienced officer, by 1962, he had participated in operations in the Naga Hills and the 1961 liberation of Goa. A sound tactician and a keen football player, Maj. Shaitan Singh was very close to his soldiers.

When Maj. Shaitan Singh arrived along with Naib Subedars Hari Ram and Ram Chander and the others, the first action he did was to address the jawans. By now, the jawans had fortified their existing bunker (the one they had taken over from CRPF) with stones, prepared a few sangars with rocks, organized a makeshift langar, and activated and tested the magneto telephones and the two wireless sets.

When everyone had assembled, Maj. Shaitan Singh looked around, smiled, adjusted his snow goggles and started to speak, '*Hum Bharat mata ki zameen pe khade hain. Dushman ko yahan se aage nahin jane denge* (We are standing on the land of

Mother India. We will not allow the enemy to go beyond this point). Clear?'

'*Ji sahab.*' The chorus echoed in the rarefied mountain air.

He continued, 'I want to tell you a few important facts. Pay attention. Rezang La Pass is at a height of around 16,000 feet. On the north of it lies the Pangong Tso Lake which runs roughly in the west-east direction and is around 130 kilometres in length. To the south of the western edge of the lake is the Spanggur Gap, one of the open areas that the Chinese can easily cross to reach the Chushul airfield. We already know that the Chinese have constructed a Class 9 road from Rutog in Tibet right up to the Spanggur Lake which lies south of Spanggur Gap.'

The major paused and scanned the faces of his soldiers. All looked straight into his eyes.

He went on, 'The Chinese will most likely cross through the Spanggur Gap. The brigade's appreciation says there's little point for the Chinese to first come south, go through Rezang La Pass, and then move 20 kilometres to the north for Chushul airstrip. Makes no sense. But the Chinese might surprise us by doing the unexpected. Therefore, we must prepare our defences to cater for all contingencies.'

After a few more details, the jawans were ordered to disperse as the major requested the three platoon commanders to stay back.

The three JCOs, Surja Ram, Hari Ram and Ram Chander, were all experienced soldiers. Maj. Shaitan Singh and the platoon commanders walked to all corners of the pass with maps in their hands to identify the positions on ground and correlate them with the markings on the map. Here, Surja Ram played an

important role and since he had already surveyed the area with Capt. Prem Kumar the previous morning, he was able to lead the party.

At that time, the strength of the company had increased to around 75 JCOs, NCOs and jawans, including the new arrivals with Maj. Shaitan Singh. But soon, the major had been assured by the CO that more jawans would be sent, which would take the total strength of the company to around 120.

After final discussions and hearing all the JCOs, Maj. Shaitan Singh shared his plan. It was decided to locate platoon 7 with around thirty-five soldiers on the forward slope on the north side of the pass under the command of Naib Subedar Surja Ram. Platoon 8 was to be located in the pass area, closer to its southern side with forty soldiers. The distance between platoon 7 and 8 was 3000 yards, i.e., a little less than 3 km. It was decided to give the nursing assistant to platoon 8 because, in the event of a direct confrontation, the casualties here were likely to be the highest. For platoon 8, it was also decided to use the already-prepared CRPF bunker. This bunker had a single-layered barbed wire fence around it which was less effective than the usual double-layered concertina coils. Platoon 8 was under the command of Naib Subedar Hari Ram who was also the senior JCO of the Charlie Company and was the most experienced of them all.

It was decided to locate platoon 9, also with forty soldiers, roughly 1 km south-west of platoon 7. This platoon would be the last line of defence to protect the command post which was decided to be located 150 yards behind platoon 9. Fifty yards to the south of the command post, the langar would be built and 150 yards behind the command post, on the downward slope, would be the section with the two 3-inch mortars.

Overall, the plan was very close to what Naib Subedar Surja Ram had proposed.

Tactically, this looked like the best way to protect Rezang La Pass with the available arms, ammunition and manpower. The company was not issued with mines, which could have slowed down the enemy's progress in the event of an attack. The company also didn't have any Recoil-less guns (RCL guns) and Medium Machine Guns (MMGs) which are ordinarily an integral part of an infantry company. The absence of these critical weapon systems was something that would hurt the Charlie Company in days to come.

To sum up, the Charlie Company only had Lee Enfield .303 rifles (600 rounds of ammunition per rifle per soldier), nine LMGs, three 2-inch mortars (one with each platoon), two 3-inch mortars and hand grenades (around 500, authorized at the rate of two per soldier and the rest as reserves).

By midday, as the soldiers got to work preparing the bunkers guided by their platoon commanders, the wind picked up. Maj. Shaitan Singh knew that they were lucky to have been sent to Rezang La in October because every year by early November, the road link to Leh was cut off due to heavy snowfall. The sun was right over their heads now and the day temperature rose a few degrees above zero. Even though the sunlight was extremely bright as it reflected off the ice on the mountain ranges around them, the weather allowed for some work, particularly by those who weren't feeling very sick.

Wearing their snow goggles, the jawans toiled hard, but soon the cold started to penetrate deeper into their bodies. As long as they worked, the heat generated by exertion warmed their bodies, but when they stopped due to breathlessness, they shivered even more.

When Maj. Shaitan Singh walked to different platoon locations, which were kilometres apart from one another, for the final inspection of the day just before sunset, he realized that the progress had been slow. With the basic implements like pickaxes and shovels that they had with them, it was impossible to break the rocky and frozen ground. By now, the temperature had started to dip rapidly once again.

He drafted another signal and sent it to the battalion headquarters requesting them to send jawans from the Pioneers. What they needed were construction implements and dynamite to loosen the surface. Naib Subedar Surja Ram had informed him that Capt. Kumar had asked for these too, but apparently no action was taken.

On 20 October 1962, Sqn Ldr Chandan Singh's AN 12 aircraft, which was on a routine sortie to the airstrip at Daulat Beg Oldi (DBO) on the northernmost edge of Ladakh, was attacked by the Chinese with LMGs. By the time the aircraft landed safely in Chandigarh, the Indian Air Force had received a demand to airlift five AMX 13 tanks to Chushul in Ladakh. The problem, however, was that the Air Force had never transported a tank in an AN 12 aircraft before. When they decided to take this on, there were two challenges: one, the tracks of the tank might damage the aircraft's flooring, and two, the excess weight on the wheel area of the aircraft, during the loading operation, might damage the wheel assembly, thereby rendering the entire landing gear useless. For the first, local carpenters were employed to create a sturdy base of wood that fitted the floor properly, and for the second, a wooden arc was prepared and piled up with

sandbags to fit under the aircraft and act as a mechanical shock absorber. Thereafter, the army and air force personnel practised the loading operation that was scheduled for 25 October 1962. But on the day of loading, one of the young army drivers had to go on leave as his wife went into labour. Since his village was close by, he was recalled and convinced that he would be sent on leave as soon as he was back after the mission. Five tanks were transported successfully. It was a remarkable feat achieved in a race against time and risking the aircraft and human lives. Finally, when the young driver returned, he was presented with a picture of a baby and his smiling wife. The commanding officer had sent a doctor from his unit to supervise the smooth delivery and the doctor brought the picture as proof. The young army driver was then given leave.

4

26 October 1962, Chushul Airstrip, Ladakh

The 114 Brigade is moved to Chushul, bringing down its area of responsibility to a more manageable 40-km border as the government decides to entrust the defence of the Ladakh sector to an infantry division. To review his strategic plan to defend the Chushul airstrip, thereafter, Brig. T.N. Raina holds a meeting with the battalion commanding officers under his command. Subsequently, Lt Col H.S. Dhingra visits Maggar Hill and Rezang La where he inspects each post and interacts with the officers, JCOs and jawans. Maj. Shaitan Singh, ably assisted by his platoon commanders, oversees the digging of trenches and construction of bunkers. The three platoon commanders are alert too and are regularly deploying jawans for observation posts (OPs) and listening posts (LPs).

Brig. T.N. Raina had been informed that the defence of Leh was no longer the responsibility of the 114 Brigade. They had done their job well, but army headquarters in Delhi had decided to restructure the organization of the entire Ladakh sector. Leh was to become a divisional HQ for the 3rd infantry division

commanded by Maj. Gen. Budh Singh. Moving to Leh were the 70th and 163rd infantry brigades along with two tank troops, a field artillery regiment, a heavy mortar battery and other supporting arms. This was made possible by Indian Air Force's AN-12s as we have already seen.

Maj. Gen. Budh Singh was a Military Cross (and a bar) awardee, his two acts of gallantry were in the Second World War at Burma (now Myanmar), where he was commanding a company as a captain.

Therefore, by 26 October 1962, Brig. T.N. Raina's brigade's tactical headquarters was shifted from Leh and established near the Chushul airstrip. According to the intelligence inputs that the brigade had received, the Chinese had started to build up across Spanggur Lake too. This meant that in the Chushul sector, an attack was likely to take place in the coming days.

Brigadier Tapishwar Narain Raina was born in a Kashmiri family on 24 January 1921. His father was the postmaster general of the Punjab state. After his education in Ludhiana, the twenty-one-year-old Tapishwar had got an emergency commission in the Indian Army, which was on a recruitment spree to augment its forces for the Second World War. Soon after becoming an officer, he was dispatched for the Burma campaign during the world war, where, due to a grenade accident, he lost one of his eyes. His name was 'Mentioned-in-Dispatches' (MID) for his gallant act during the war.

By 1962, the forty-one-year-old officer was known as a 'soldier's soldier' due to his compassionate treatment of the jawans. There was a reason for this. In the Burma campaign, from where he began his career as a platoon commander, he had worked closely in life and death situations with the jawans and knew exactly what their operational and emotional

needs were. In army circles, he was more popularly known as 'Tappy' Raina.

Brig. T.N. Raina's first action after establishing the tactical headquarters in Chushul was to call for an ops meeting of his battalion commanders.

The previous night, the soldiers trained for preparing sand models had already created a detailed model of the operational area.

Present at the meeting besides Brig. T.N. Raina was Maj. Jasjit Singh, brigade staff officer. As soon as all four COs arrived, Brig. Raina began to explain his strategy, 'Gentlemen, our brigade is responsible for the defence of the entire Chushul area. This area extends from south of the Pangong Tso Lake here,' he looked up at the COs after pointing to the edge of the lake and continued, 'up to a place called Tsaka La mountain pass in the south here. The total frontage that has been entrusted to us to defend is 40 kilometres. For this, we have your four battalions. I don't want you to worry about ammunition. The Indian Air Force is flying in daily. Soon, we will have choppers too, so that the units can be supplied with ammunition and rations right at their deployed positions.'

Brig. T.N. Raina had been constantly monitoring the evolving situation. Besides the two battalions, namely, 13 Kumaon and 1/8 Gorkha Rifles, he also had 1 Jat LI and 5 Jat under his command. Should the Chinese approach the area from the north, the brigade commander had deployed 1 Jat LI north of the Spanggur Gap in an area called Tokung which was on the southern bank of the Pangong Tso Lake. Similarly, to protect the airstrip from the south, 5 Jat was deployed in the vicinity of Tsaka La Pass.

Brig. T.N. Raina paused, looked at Lt Col H.S. Dhingra, CO, 13 Kumaon, and said, 'I am aware that Rezang La is an isolated post and you have a company there. But frankly, as we have appreciated it before, an attack is not likely to take place from that side. They will only come from there if they want to cut the Tsaka La road, which, as we have seen before, is too far-fetched. Can you tell us, on the sand model, about the detailed disposition of your companies?'

Lt Col H.S. Dhingra cleared his throat and said, 'Sir, as directed by the brigade, we are guarding the east and south-east of Chushul,' he pointed this out on the sand model and continued, 'Alpha Company of 13 Kumaon, under the command of Major G.N. Sinha, is the battalion reserve, positioned at the battalion headquarters on high ground near Chushul here. The Bravo and Delta companies are on Maggar Hill that's here between Spanggur Gap and Rezang La Pass.'

'All right, one moment, who's in command of these companies right now?'

'Sir, Captain Raghunath V. Jatar.'

'Okay, but I was told he is on leave.'

'Yes, sir, he was on leave at USI in Delhi to prepare for the staff college exam. But he is back and is currently with these companies at Maggar Hill.'

'Good. So, you recalled him, right?'

'He was here before I could send a telegram, sir. When I spoke to him, he said as soon as he heard that war had broken out, he left Delhi immediately.'

'That's what any good officer would do. Continue, Colonel Dhingra.'

'Yes, sir. And the Charlie Company is in the Rezang La Pass area under the command of Major Shaitan Singh.'

'Has Major Shaitan joined his company? You had said he was back at Baramulla for handing over the QM charge?'

'Yes, sir, he wrapped it up fast, stayed for the required duration at Leh to acclimatize and as we speak, he has just arrived at Rezang La.'

'Good. He needs to saddle up fast. Even though attack is less likely from there, we can't take any chances.'

'Yes, sir.'

'Okay, gentlemen, let's now review our other positions. North of Maggar Hill is the Spanggur Gap and on the other side are Gurung Hill and Gun Hill. These two hill features and the gap are now the revised responsibilities of 1/8 Gorkha Rifles.'

The battalion commander of 1/8 Gorkha said, 'Yes, sir.'

'Can you defend these positions after our withdrawal from Srijap and Yula?'

The CO replied, 'Yes, sir.'

'The brigade is proud of Major Dhan Singh Thapa and Subedar Min Bahadur Gurung. India is blessed to have soldiers like them.'

There was silence for a few seconds. This was followed by reviewing the deployment of the units belonging to 1 Jat LI and 5 Jat.

All the officers present during the ops briefing were aware that since the last few days, the Chinese boats had been seen patrolling Spanggur Tso Lake. From the Indian posts, the soldiers had also spotted the Chinese commanders open their maps and stare at the Spanggur Gap. This was a deliberate decoy that the Indians would realize weeks later. In addition, the troops had also heard a lot of blasts which indicated that the Chinese were strengthening their bunker positions in the area beyond the lake.

After a pause, as all present continued to look studiously at the sand model, Brig. T.N. Raina finally spoke, his voice slow and deep, 'Pay attention; there are only a few approaches that the Chinese can take to attack the Chushul airstrip. Since the shortest route is through the Spanggur Gap, our brigade's focus should be on it. We will make sure that our artillery guns and heavy mortars are ready to pound them in that direction. We have concentrated our RCLs in that direction too and the process of mining the approach during the night should continue. In addition, we have deployed armoured troops there.'

Everyone said, 'Roger, sir.'

Brig. T.N. Raina continued, 'Gentleman, this is what the security of our 40-kilometre frontage of Chushul airstrip looks like. Questions?'

One CO said, 'Sir, I think we should man other approaches too.'

'I know. But we don't have time for that. The attack is imminent and we know the direction it will come from. Let's focus on making that impregnable. Yes, if they allow us more time, we will man other approaches too. For the moment though, since our intelligence is clear and we know the PLA's intentions, let's man all our areas except Rezang La and the area south of it where 5 Jat is stationed.'

There was silence now and Brig. T.N. Raina added after a few seconds, 'Gentlemen, the war is already on. There seems to be a temporary pause now. Let's use our resources judiciously. There will be tanks, more artillery, more troops flying in, in days to come and we will allocate them. Until then, let's focus on the Spanggur Gap. Right?'

'Yes, sir.'

'Look, we have approximately 4000 soldiers and we have only one mission: to save Chushul airfield from falling into the enemy's hands. Clear?'

All four battalion commanders replied in chorus, 'Yes, sir.'

After discussing a few more points, the meeting ended.

Over the next few days, the Indian Air Force transport aircrafts kept on regularly flying men, stores, rations and ammunition just as the brigade commander had promised. The aircrafts used in these operations were the Russian AN-12s and the American Fairchild C-119s. This sustained support of the Indian Air Force played an important role in helping the army fortify their positions swiftly.

But these missions were not easy. Unprecedented as they were, they carried considerable risk to men and material. One of the primary complications was the fact that the airstrip was not meant for such an operational load. It now had to cope with six AN-12 flights and about eight C-119 flights daily and frequently became unserviceable. The men of 9 Field Company of the army had a hard task keeping it in repair and, therefore, to assist them, the divisional engineers were diverted for this task also.

Notwithstanding the risk, human ingenuity and will resulted in making the logistical role of the Indian Air Force central in preparing the entire Ladakh area. Consequently, by 13 November 1962, a total of 95 AN-12s and 57 Fairchild C-119s would land at the Chushul airstrip.

* * *

Located at an altitude of 14,300 feet, Chushul is a small border town where almost everyone in 1962 was uneducated. The main

profession of the locals was raising sheep, goats and yaks, besides travelling once a year to Tibet for trading. From November to April each year, the village was cut off from the rest of the country due to heavy snowfall and absence of roads. At that time, hockey was popular across the nation as India had remained unbeaten from 1928 to 1956 in the Olympics. In Chushul, however, during the winter months, when people did not have much to do, ice hockey was a popular sport.

The road that had carried the soldiers of the 114 Brigade to Chushul in 1962 was a new unmetalled one constructed by the Border Roads Organization (BRO) in the first week of October. BRO was just two years old at the time and was doing a commendable job in the high-altitude areas of both NEFA and Ladakh by constructing roads, bridges, airstrips, helipads, tunnels, etc. It was a gargantuan responsibility for the new organization.

The Chushul airstrip was an ALG that required maintenance work every time an aircraft landed or departed. It was a temporary airstrip but in terms of its operational usability, it was the lifeline for the build-up and strengthening of the Ladakh sector along with the airstrips at Leh, Daulat Beg Oldi, Thoise and Fukche elsewhere in the region as mentioned earlier.

On 26 October 1962, in the Rezang La Pass area, as the troops of the Charlie Company were at work, there was only one thing on everyone's mind—that the Chinese attack could come at any time. It was like the quiet before the storm. All the forward posts manned by the Indian Army north of Pangong Tso Lake had either been wiped out or had retreated to more defensible positions inside the Indian border.

Since the arrival of Maj. Shaitan Singh, not just the platoon commanders, but also the other jawans and the NCOs of the

unit were in full *josh*. The emotional bond between an officer and his company or battalion in the Indian Army is a unique one. It is nurtured over months and years as everyone trains, eats and fights together. For soldiers in the army, a unit is like a home where everyone is on their own. The competition is not with each other, but, during peacetime, it is with other units and during the war, it is against the enemy.

By the second day since the arrival of Maj. Shaitan Singh, the three platoon commanders had completed the marking of the trench positions. These were three-men L-shaped trenches that would be manned by the sections under the command of the respective platoon commanders. Each platoon had three sections and it was decided that these would be manned by a section commander and two jawans. Besides these sections, the mortar positions had also been finalized. The boundaries of these trenches, just like the boundaries of the platoon headquarters, had been marked with small stones picked from the pass area. The jawans worked hard trying to dig with their shovels and pickaxes but the progress continued to be slow. A few jawans who were in their teens or early twenties had by now become almost acclimatized to the altitude and these were the ones who toiled the hardest.

Maj. Shaitan Singh had established wireless communication on set 31 with Capt. Raghunath V. Jatar, who was the post commander of Bravo and Delta companies on Maggar Hill that lay 5 miles north of Rezang La. Maj. Shaitan Singh had also communicated with his CO a few times to update him regarding the progress of the readiness of the Charlie Company. In fact, the CO was scheduled to visit the next day and therefore, Maj. Shaitan Singh walked to the platoon positions one by one and urged the jawans to work even faster.

In wireless communication, he had started to face a bit of trouble though. The field telephone communication between the platoons and the company headquarters and between the company headquarters and the battalion headquarters was working well. But during late afternoons and the nights, particularly when the radio operators moved in the area, the VHF was not reliable for communication outside the area of Rezang La due to screening caused by the hill features. The batteries of the VHF sets were also giving them trouble due to the freezing temperatures.

On 26 October 1962, in Chushul, just after the ops briefing that he had attended at the brigade headquarters, Lt Col H.S. Dhingra left for Maggar Hill. There were two reasons for this. One, he wanted to meet Capt. Raghunath V. Jatar himself, as he had only spoken to him on the field telephone since the latter's arrival from Delhi, and two, he wanted to pass the brigade commander's appreciation and orders after monitoring the progress of the preparations in the field.

Lt Col H.S. Dhingra and Capt. Raghunath V. Jatar shared a common love for the game of hockey. Almost every evening, in Ambala and thereafter in Baramulla, they played the game together with the troops. This made their mutual understanding much better.

The CO's visit took up the rest of the day and by the time he reached back at the battalion headquarters on high ground close to Chushul airfield, it was way beyond sunset. Before calling it a day, he sent a message to the Charlie Company at Rezang La that he would be arriving in the morning for a visit.

Before Lt Col H.S. Dhingra arrived the next morning, i.e., on 27 October 1962 at 11 a.m., after a three-hour ride on the back of a mule, Maj. Shaitan Singh had already visited

the platoon positions spread over an area of 3 km once again. By the time he was back, it was 10 a.m. He quickly got down to updating the map that he had prepared and placed it on a stand.

By the time the CO arrived a few minutes before eleven, he was there to receive him. The CO responded to the company commander's salute with matching crispness and said, 'Good morning, Major. So, how's it going, young man?'

'Good morning, sir. The boys are getting used to this altitude now and we are making progress. But we need specialized construction equipment.'

The two officers sat in camp chairs right outside the company headquarters.

By now, the langar was fully operational. Pressure cookers had arrived and they had sufficient quantities of rations. As soon as tea was served to them, the CO said, 'I know you need help with the digging of trenches and bunkers, but the truth is, the Pioneers are very busy, Major. There's a lot that needs to be done to fortify the entire Chushul area. But I will make sure that they come here soon.'

'Sir, we are working as hard as we can.'

'I know. The Charlie Company is the best, after all. These are my boys. I too had the proud privilege of commanding these tough boys from Haryana when I was a major.'

The CO paused to take a sip of tea from the enamel mug.

'Yes, sir.'

The CO continued, 'Your OPs and LPs are doing a good job as I can see from your sitreps. The IB is sharing regular information that they are collecting from the local spies too. So, we are good.'

They were quiet for a minute before the CO spoke again, 'The brigade's appreciation says the Chinese won't attack from your side, major. They will, in fact, attack from the Spanggur Gap, where we are well-entrenched in strong and defensible positions right now. So, whenever the Chinese troops make the ill decision to come through that gap, we will give them a hot reception. They shouldn't think of Chushul as a weak and half-hearted garrison like our forward posts.'

The CO placed his empty mug down and got up. The major jumped to his feet too.

'Sir, the platoon positions are ready for your inspection.'

With that, the two officers started to walk towards the locations where the platoon positions had been finalized. Maj. Shaitan Singh opened his map case and took out the detailed quarter-inch map. After a few steps, when the CO stopped and looked around, the major grabbed the opportunity and started to explain the land features around them, referring to the map and pointing towards the corresponding directions.

The CO took the map in his own hands and reconfirmed what the major had just said. The fact that the features were marked with a china-graph pencil made the whole map-to-ground correlation easy. After a few moments, they started walking again.

They first arrived at platoon 7. Naib Subedar Surja Ram stepped forward and saluted crisply. The CO returned his salute and looked around. The jawans had stopped midway to acknowledge the CO's arrival. He looked at them as they straightened their bodies, inflated their chests and pulled their arms by their sides in attention.

'*Kaise ho aap log? Kafi kaam kiya hai itne chote auzaron se. Jaldi hi Pioneers ayenge aapki maddad ke liye* (How are you doing? You have worked really hard with such a little equipment. The Pioneers will soon come to help you.)'

The jawans looked at the CO emotionlessly. They were not expected to respond and they didn't. The platoon commander also waited for CO's next command.

'Surja sahab, I have heard about you from Major Shaitan Singh. He says he hasn't worked with you earlier, but he has received feedback from your previous unit about your attitude and capability.'

Naib Subedar Surja Ram didn't flinch.

The CO continued, 'Surja sahab, *guns ki bayin hadd aur dahini hadd double check ki hai na?* (Surja Sahab, I hope you have double checked the left and right limits of the guns?)'

'*Ji sahab. Major sahab bhi yahein the* (Yes, sir. Major sahab was also present).'

'Very good. The Charlie Company is the best I know. Keep working, I'm proud of you.'

With that, the CO and the major moved towards the other two platoons and there too, the CO's presence made everyone feel reassured.

Before leaving Rezang La, Lt Col H.S. Dhingra looked at Maj. Shaitan Singh and said, 'If the enemy dares to come from here, major, I want you to take the best course of action.'

'Sir, the Charlie Company will fight till the last man, last bullet.' With this, Maj. Shaitan Singh saluted.

The CO smiled, returned the salute and left immediately after that.

The CO's visit produced immediate results and right on the next day, the Pioneers arrived with heavy construction

equipment and dynamite. With that, the digging for bunkers and trenches to be used for the sections and the platoon command posts sped up. Although the work started to show results on ground almost immediately, it would still take a few more weeks for the company to be properly entrenched.

In the interim, the danger of a swift Chinese attack could not be wished away. Therefore, right from the first day, the action related to LPs and OPs had already been established. Simply put, LPs comprise two or three jawans who keep a listening watch some 100 yards ahead of the platoon posts. Their main task is to give an early warning if they hear or see the enemy approaching. It's a boring job because all you have to do is wait. Troops can't even speak to each other, listen to the radio, or indulge in reading or any other activity. For hours the eyes and ears have to be kept strained ahead.

OPs comprise of two or three jawans who are sent up to a mile or more ahead of a unit's defence position, ideally on a round-the-clock basis, to monitor the activities of the enemy. Unlike the LPs, the OPs have a radio to convey their observation. This is a spying activity and has to be done in stealth mode. Sometimes, OPs can also be static temporary positions that merge with the surroundings to escape enemy detection. In the case of the Charlie Company, the OPs operated from seven in the morning to seven in the evening, conveying the latest information regarding what the enemy was up to by radio during their watch. For the night, they were replaced by a new set of two jawans who stayed till seven in the morning, when, once again, the day jawans returned and took over. This continued in rotation.

So far, the LPs had not reported anything unusual and the OPs had been conveying the same information that the Chinese

side visible to them appeared to be inactive with only a few
soldiers noticeable on routine patrol. This was a good sign and
meant that the Charlie Company had time. The reports of the
LPs and OPs were regularly relayed to the battalion headquarters
by Maj. Shaitan Singh through sitreps.

Since the langar was fully operational now, the company's
weekly menu was being followed. Because of the extreme
high altitude, the ration scales were also better than the high
altitude allowance of Leh as already seen. In addition, there
was sufficient availability of tea, coffee and even cocoa. One
of the most loved beverages however was jam-paani, which
was nothing but an innovative drink of jam mixed with warm
water. It gave the troops instant energy and made them work
harder and longer as they assisted the Pioneers in digging the
bunkers and trenches.

On 21 October 1962, when an Indian transport aircraft flying
over Ladakh reported a 2-mile-long column of Chinese military
vehicles heading towards Chushul along the road from Rudok
in Tibet, alarm bells started to ring in the army headquarters and
the defence ministry. Until then, the Indian intelligence didn't
have any idea about the military build-up on the Chinese side
of the Ladakh border. This was going to cost India heavily. The
Indians were ignorant of the aggressive road-building activity of
the Chinese that had connected all their border posts to their
support bases in the deep. Due to this, the PLA's mobility of
troops, artillery and stores was swift. Compared to this, the
Indians in Ladakh had just completed the road that connected
Srinagar to Leh. A jeepable road that connected Leh with

Chushul was also made weeks before the Chinese attacked India as we have seen before. All other thirty-six forward Indian posts were still connected by mule tracks, which took days to reach and had obvious load-carrying restrictions.

5

30 October 1962, Rezang La, Ladakh

As snow clothing arrives and the Pioneers bring dynamite sticks and superior digging tools to assist, the speed of preparation of the bunkers and trenches in Rezang La gets a boost. Maj. Shaitan Singh, along with the section commander of the 3-inch mortar section, Naik Ram Kumar, surveys the probable enemy approaches and ranges the mortars, designating them with code words. Meanwhile, new recruits, who had arrived at the Chushul airstrip a day earlier from Ranikhet, are deployed to Rezang La to make up for the shortfall in manpower. With that, the company's size increases to 120. The company commander is also seen interacting with the jawans, as he is ably assisted by the Company Havildar Major (CHM), Harphul Singh.

It had been one week since the arrival of the Charlie Company at Rezang La in Ladakh. The cold had intensified and now the night temperature hovered around minus 18 degrees Celsius. The snow clothing had finally arrived a day before, but the coat parkas were not of the quality that

could withstand the bone-chilling cold. The troops, however, welcomed these; as one of them remarked, 'Something is better than nothing.'

One of the things that the harshness of the weather and the poor quality of clothing could not take away from the jawans was their fitness. Young well-trained village-bred boys, who were raised on desi-ghee and top-quality milk, were ready for action. These jawans were more or less acclimatized now and even with the poor quality of clothing and moderate quantity of food, their performance had improved. In addition, the support of the men from the Pioneers branch in digging trenches and constructing bunkers had further enlivened them. While there had been no alarming threats reported by the LPs and OPs, the Charlie Company continued to prepare their defences with all the available resources.

According to the All India Radio reports that the troops tuned in to every evening, the pause in Chinese attacks all along the Sino–India border since 24 October 1962 continued. Indeed, it was a period of lull and it was believed that the politicians of the two countries were trying to resolve the border crisis diplomatically and politically. The Charlie Company had, of course, no way of knowing that all the government's efforts would fail, and, in a little over two weeks, the PLA would renew its attacks on all the sectors along the border.

On 30 October 1962, the Charlie Company received a message that forty-seven new recruits had landed at Chushul airfield at ten in the morning on 29 October 1962 and that day, after they had been addressed by Lt Col H.S. Dhingra, they would be escorted to Rezang La.

At seven that morning, as Maj. Shaitan Singh had just finished his breakfast and was preparing to proceed for visual

inspection of the various platoon posts, he heard a large explosion. He ducked instinctively and saw smoke rise in the distance. But, within seconds, he realized that it was another of those dynamite explosions that the Pioneers had been detonating periodically since their arrival. Everything was going according to plan and he was confident that the company would be ready in all respects by mid November.

The major wore his snow goggles to control the blinding white glare of ice all around and got up from his camp chair. Then he walked behind the company headquarters' post, where the 3-inch mortar section had been sited and where digging was in full swing at the moment. Since the 3-inch mortar was the largest and the deadliest weapon that the company possessed, he wanted to be specific with not just its location but its direction and ranging too.

The first person Maj. Shaitan Singh saw there was Naik Ram Kumar who was the section in-charge of the 3-inch mortar post located 140 yards behind the company headquarters on a downward slope. Ram Kumar was an exceptional soldier and the major trusted him completely even though Ram Kumar had been demoted from Havildar to Naik due to a recent incident related to convoy discipline.

Ram Kumar stopped working as he saw his commander approach, saluted him and cheerfully said, '*Ram ram sahab*. Welcome back to the unit.'

'Thank you, Ram Kumar. You must be missing kabaddi here.'

'Yes, sir. Here, we are spending our energy only on building our defences. Kabaddi *bahut khel liya* (We have played enough kabaddi).'

The major smiled and asked, 'How's Mishri devi? Got any letters from home?'

Mishri devi was the name of Ram Kumar's wife who was back in his village Bahrampur in the Rewari district of Haryana.

'Yes, sir. She is doing good.'

He patted Ram Kumar's shoulder and said, 'That's good to know . . . '

After a pause of a few seconds, in which the major looked around and acknowledged the *Ram-Rams* of others working in the vicinity, he continued, 'Ram Kumar, let's finish the laying exercise of the 3-inch mortar today.'

'Yes, sir. Today, the visibility is good too.'

'Yes, and that is why it is the right time for us to conduct the mortar survey. You come with me. The others in your section can go ahead with the fortification of the mortar post.'

Nk Ram Kumar laid down his tools and started to walk alongside the major.

After a few steps, the major said, 'So, how does it feel to become a naik once again from havildar? Anyone making fun of you?'

'Sir, they still think I'm a havildar, because that's what I think in my head.'

The major laughed, 'You know what, among the officers too, we have a few who behave as if they are colonels even when they are actually majors. Such officers go very far, Ram Kumar.'

'Are you one of them, sir?'

The major turned to look at Ram Kumar, a mysterious twinkle in his eyes, 'What do you think?'

'I'm not sure, but I'm sure of one thing, sir.'

'And what is that?'

'Since you are so calm and composed all the time, I'm sure you will become a general one day.'

Maj. Shaitan Singh laughed, 'If I become a general, Ram Kumar, you will be a subedar major and I will get you to whichever place I'm posted.'

'Thank you, sir.'

They walked in silence for a few minutes.

'Ram Kumar, though you hold the rank of a naik now and the 3-inch commander should ideally be of havildar rank, I have still positioned you there. Do you know why?'

'Because you trust me, sir.'

'Exactly. I have seen you handling the 3-inch mortar . . . let's do a proper survey today, find out the probable enemy approaches and range our mortar.'

'Yes, sir.'

By now, they had crossed the platoon 9 position on the forward slope and stood looking east, in the direction the OPs had been reporting the enemy's position.

Both turned as they heard a sound right behind them. It was Naib Subedar Surja Ram.

'*Sahab, Ram Ram*!'

'*Ram Ram*, Surja sahab.'

'Sahab, what's the order?'

'Surja sahab, Ram Kumar and I are here to identify enemy approaches and mark them. Where do you think they will come from?'

Surja scratched his chin and said, 'Sahab, I think they will come in the night through the nullahs. Somewhere between three and four, early morning.'

Ram Kumar said, 'Sahab, from what we have learned so far from the NEFA and Srijap attacks is that the Chinese use human waves.'

The major's face was now taut with seriousness, 'Yes, and one more thing, they use surprise as a strategy, like they had used in Korea.'

'Sir, we will defeat every attack of the Chinese. They might have the numbers, but we have *Dada Kishan ka ashirwad* (Lord Krishna's blessings).'

'Absolutely.'

They were quiet for a few seconds. Then the major asked, 'Suggest a few names for the target positions, Ram Kumar.'

Ram Kumar replied, 'Sir, let's use the name of birds, like *tota, maina, bulbul, kabutar, mor, chidiya, wagairah.*'

'Okay.' With that, the major took a few more steps forward.

Ram Kumar took out a paper and pen from his pocket and began to write down the positions the major started to dictate on the basis of likely ranges, charges to be used for the distance and the applicable trajectory. The exercise took them several hours.

Meanwhile, Naib Subedar Surja Ram went back to his platoon post. Now, he had to do the same for his platoon's 2-inch mortar. The only difference, however, was that the major had the complete company's defence in mind due to the greater range of the 3-inch mortar, whereas Surja Ram had his platoon's defence in mind as he had a 2-inch mortar.

* * *

The previous morning at Chushul airstrip, as mentioned before, an AN-32 aircraft had landed at around ten. Along with stores, arms and ammunition, it also had a draft of forty-seven young Ahir recruits who had been pulled out of their training at Kumaon regimental centre in Ranikhet in the final stages.

The jawans stepped out of the aircraft, involuntarily pulled their shoulders inwards to adjust to the cold, squinted in the bright mountain sun and began to stand in a formation just as they had been trained. At that time, these young soldiers were not aware of what was in store for them in the coming days.

When they had formed up on the tarmac, a JCO from 13 Kumaon escorted them to the edge of the airfield. Here, they were asked to wait. A few minutes later, two trucks arrived and they were ordered to get inside. The young recruits were then taken to the battalion headquarters where a hot breakfast awaited them. After eating, they were directed to rest until the next day and not exert themselves for the fear of developing high-altitude sickness.

Finally, the next day, at two in the afternoon after lunch, i.e., on 30 October 1962, they were made to stand once again in a formation for the address of the CO, 13 Kumaon. The moment has been appropriately captured in the war diary of 13 Kumaon as below:

'A new draft of 47 arrived at Chushul. Travelling in an aircraft for the first time, on great heights and because of the rarity of air, most of the boys were badly affected. Lt Col H.S. Dhingra, CO, addressed them the next day and gave instruction that they will be gradually inducted to the pickets they were to hold. It was queer scene to see their innocent faces, nose-blowing beyond their control and body swaying with dizziness.'

—*War Diary, 13 Kumaon Battalion*

The recruits were escorted to Rezang La immediately after the address, where they arrived three hours later, just before sunset.

Meanwhile, after a long day, as Maj. Shaitan Singh was returning to the company headquarters from the forward platoon positions at five in the evening, his eyes fell on the young recruits. He called the CHM Harphul Singh.

Hav. Harphul was an extremely agile NCO with great observation skills. The jawans trusted him and he lent his shoulder to anyone in the company who needed to lean on him and cry. Harphul's natural qualities fitted his responsibility so well that he always knew the pulse of the troops.

He arrived on the double and saluted the major, '*Ram Ram sahab.*'

'*Ram Ram*, Harphul. How are these young recruits feeling?'

'Sir, they have been sent straight to 13,000 feet. Yesterday, they were in Chushul and today they are here at Rezang La at 16,000 feet. Eight to ten of them are feeling unwell, but the others are okay.'

'High-altitude sickness takes around twenty-four hours to set in, Harphul. Since it's been more than twenty-four hours in these heights for them, I don't think anyone else is likely to fall sick now. But we must watch them carefully, particularly the more serious cases. Ask Sep. Dahiya to give them medicines, monitor them closely and let them have a lot of rest. No duties for them for the next ten days unless the situation changes. Clear? They are very young and well-trained, but all that can be put to use only if their bodies adjust to this altitude.'

'Yes, sir.'

As the major sat down in his camp chair, he saw the CHM briefing the young soldiers and ordering them to slowly walk towards the allocated locations in the half-ready bunkers.

After an hour, Maj. Shaitan Singh was on the magneto landline phone for the evening's operational report to Lt Col H.S. Dhingra.

The CO came on line within a few moments, 'How's the situation, major?'

'Sir, all is well. The new recruits have reached us. But their condition is bad. No acclimatization at all.'

'I know, I felt bad for them too. But it's war time, son. We are all in this together.'

'Yes, sir.'

'How's the progress on the preparations of the bunkers and the trenches?'

'We are working at full pace, sir. Should be done in another ten days or so. That's our revised estimate.'

'OPs and LPs?'

'No significant reports, sir.'

'I know, this is an unsettling calm.'

'What about the intelligence reports, sir?'

'It's still the same. The build-up has been constant north of Pangong Tso, not so much in the Spanggur Lake side. But, unlike India, China has the wherewithal for rapid build-up any time they want due to the roads and easier terrain on their side of the border.'

'We are on the job, sir. Even now, if the PLA tries to do any misadventure, we will give them a bloody nose for sure.'

After the call, Maj. Shaitan Singh retired to his bunker. It was deathly quiet outside the company headquarters post. Surprisingly, there was no wind. The unpredictability of the weather was the only predictable feature in the desolate moonscape the Charlie Company was deployed at. He closed his eyes, his mind refusing to sleep.

The next day, at five in the morning, Sep. Ram Chander, who worked as Maj. Shaitan Singh's batman in addition to being the radio operator, arrived at the entrance to the command post. He paused to look around. The surroundings were dull white even though sunrise was still more than two hours away. It had snowed the whole night and the temperature was around minus fifteen degrees Celsius. The only solace was that there was no wind.

The major was inside and the batman wondered if sahab had woken up. Probably not, because, as he strained his ears, bringing his ear closer to the bunker door, he heard no sound. The major woke up every day at around five thirty, so there was still time, he thought.

From where the batman stood, he could see movement of the jawans to and fro from the langar. A few junior sepoys waved at him and he waved back. He was in a position of privilege as his job was to look after the major sahab. His experience with Maj. Shaitan Singh had been very good and he was treated with respect and fairness. Therefore, he put his heart and soul into everything he did to make sure the major sahab was comfortable and ready for action at all times. His duty was to do the major sahab's personal jobs, including preparing his uniforms, acting as his runner to call anyone the major demanded, and bringing him food and tea.

He heard a sound from inside. The batman knocked and spoke loudly, '*Ram Ram, sahab.*'

'Come in.'

The batman pulled the door open slightly and peeped inside, '*Ram Ram, sahab.*'

'Ram Ram.'

'Sahab, *kya laun,* chai, jam-paani *ya* coffee (Sahab, what should I get you, tea, jam-water or coffee?)'

The major was sitting in his bunker bed. He looked at his batman and said, 'I don't want anything now. Wait for some time.'

The batman stepped outside, closed the door and began to wait.

Inside the post, Maj. Shaitan Singh's thoughts were elsewhere. He was thinking about his wife Shagun and son Narpat who were both in Jodhpur. In this cold desert, so far away from his native place, he missed them terribly. What would happen to them if he was killed in this battle, he wondered. The thought depressed him.

He knew full well the risks of his job. Right now, there were only two things that could save his life: better preparation and luck. Since he had no control over the latter, he knew everything rested on their level of preparation. He was aware that the Charlie Company had the strongest men and they were putting inhuman strength to fortify their defences in the minimum possible time. When the time came, he knew, his men would inflict a lot of damage on the enemy. But from what he knew, the enemy was ten times more than them and the enemy had better weapons.

His thoughts turned towards the operation in the Naga Hills and the liberation of Goa in 1961 in which he had participated as an officer of the Kumaon Regiment. They had achieved these formidable tasks with elan and this time around too, as long as they played by the rules and trusted their tactics and the exemplary bravery and courage of their soldiers, they would come out victorious. The thought eased his mind a bit.

Outside, CHM Harphul Singh approached the batman and asked, 'Sahab has woken up?'

'Yes, sir.'

'Can I go and talk to him?'

'Sir, not now.'

'Why? What happened?'

'Sahab seemed a bit gloomy, I think. He asked me to wait.'

Harphul Singh took a deep breath and said, 'Sahab is worried about our company. He is also worried about our families?'

'Yes, sir.'

With that, the CHM walked away, saying he would speak to the major later.

Inside, Maj. Shaitan Singh's thoughts turned towards his men. The company was in full strength now. Including the forty-seven jawans who had joined the company last evening, he had 120 jawans under his command now. That meant 120 families back home. Young sons of their mothers and fathers, young husbands of their wives, and young fathers of their daughters and sons. They were also brothers to others and many he knew were the sole breadwinners for their families.

How is my family different from theirs, he wondered. The major knew it wasn't.

Maj. Shaitan Singh called his batman, 'Today, I will take my tea with the jawans of platoon 8.'

With that, Maj. Shaitan Singh started to walk in the direction of platoon 8, the batman scurrying behind him. The major had already changed into his coat parka, his head covered by the faux fur hood. The walk of one-and-a-half kilometres was covered in approximately twenty minutes.

Naib Subedar Hari Ram was standing outside and giving instructions to his men. As soon as he saw the major, he came to attention and said, '*Ram Ram, sahab.*'

'*Ram Ram*, Hari Ram sahab. I've decided to take my morning tea with your platoon today.'

Naib Subedar's face broke into a smile, 'Sahab, thank you.' He signalled to one of the jawans who was standing next to him and the jawan vanished inside the bunker.

Platoon 8 had the ready-made bunker which the Charlie Company had inherited from the CRPF on 24 October when they had arrived. Since it was small in size, the jawans had dug around it and were in the process of increasing its size. Not far from this platoon headquarters, other jawans were digging L-shaped trenches for section posts.

'So, how is the progress?'

'Sir, the speed is good. We are waiting for the Pioneers to show up. They should be here any moment now.'

Maj. Shaitan Singh moved around the platoon headquarters and spoke to the jawans one by one.

'Ram Singh, how are you?'

A young sepoy smiled and said, '*Ram Ram, sahab*. I'm fine.'

'Tara Chand, fit *hain na*?'

'*Haan sir, bilkul. Ram Ram sahab.*'

'Sher Singh, how are you?'

The jawan who was addressed took a few seconds to reply, 'Sir, I am okay.'

'Good. Keep up the josh, boys. Please continue with your work.'

With that, Maj. Shaitan Singh and Naib Subedar Hari Ram walked a little distance away from the platoon headquarters. As soon as they stopped, a jawan approached them with two glasses of tea in enamel mugs.

Maj. Shaitan Singh took a sip and remarked, 'Just as I expected, very sweet, but very good tea.'

'Thank you, sir.'

'Tell me, what's the problem with Sher Singh? He seems depressed.'

'Sahab, his mother is not well. He wants to go on leave but since leave has been stopped for everyone in the company, I had to turn down his request. He's very attached to his mother and it's affecting his state of mind.'

'Hmm.'

After this, they drank their tea in silence. When they finished, Maj. Shaitan Singh said, 'Let me talk to Sher Singh.'

With that, he walked towards Sher Singh once again.

'Sher Singh!'

The sepoy who was digging with his head down looked up. Hearing his name called by the company commander, others around him stopped working too.

'What happened? Your mother is not well?'

Sher Singh nodded and his eyes began to tear up. Maj. Shaitan Singh took a step forward and hugged him. The sepoy broke down and started crying. The company commander didn't leave him for one full minute. It was only when his breathing stabilized and his sobbing slowed down, did the major break the hug.

Then he said, 'Look, no one can leave this post right now. And I have no way of forecasting who will finally go home alive from here. But I pray to God that *you* go back alive.'

The sepoy nodded faintly.

The major continued, 'I want to make a promise to you today. If I return alive from here and you don't, I will look after your mother for my entire life. That's my word.'

The sepoy looked up into the major's eyes and nodded, 'Thank you, sir.'

Now, the major turned and addressed all those who were hearing this conversation, 'My brave soldiers, all of us want to leave this place after winning and we will win. But, as you know, there's no way we can do this by stepping back. The only way we can win is if we stop the Chinese right here. Tell me, can we defeat the Chinese?'

'*Ji sahab*,' the handful of jawans present shouted in chorus. The sound of their optimism and josh travelled far into the icy mountains.

'Very good. Now back to work.'

From platoon 8, with his batman by his side, Maj. Shaitan Singh walked back towards platoon 9.

The major spoke to his batman as he walked, 'Yesterday, we had received some almonds from battalion headquarters. Where have you kept them?'

'In your bunker, sir. That's your quota.'

'Do one thing, go and get me a packet.'

The batman ran off as the major continued towards platoon 9.

This platoon was the final line of defence for the company headquarters and was located approximately 300 yards to the east of the company headquarters right behind an existing spur. On the south edge of this spur, section one was located. The section commander of this was Nk Bhup Singh. Section two was located on the north edge of the spur. The section commander of this was Nk Budh Ram. Towards the east from the platoon headquarters, at a distance of 400 yards, was a knoll and, taking advantage of this natural feature, section three was located right behind this.

As he arrived, the company commander was greeted by Naib Subedar Ram Chander, the platoon commander.

Five-feet-ten-inches tall and lean-built, Ram Chander had nerves of steel. The major knew, even if the Chinese somehow could defeat platoons 7 and 8, they would be in for another big surprise here. The defences were rock-solid and so were the josh, training and intelligence of the platoon commanders.

Naib Subedar Ram Chander saluted the company commander, '*Ram Ram, sahab.*'

'*Ram Ram.* How's the preparation and josh of your platoon?'

'Sir, we are ready to kill anyone who even looks in our direction. The weapons are being serviced and oiled, the grenades are ready, the LMGs are ready with ammunition belted, and so are the individual rifles. The jawans are saying all that is remaining is for the Chinese to show up.'

The josh and preparations pleasantly surprised Maj. Shaitan Singh. He congratulated the platoon commander, 'That's good, now we must finish everything fast and be a hundred per cent ready. How many more days do you need to consolidate all posts?'

'Sir, one week, maximum. We are working day and night.'

Meanwhile, the batman arrived with a packet of almonds in his hand.

The major took the packet and spoke loudly for everyone to hear, '*Jawano, pay attention, waise fauj mein dimag ka to koi kaam to hain nahin. Humko to sirf dushman ko goli marni hai. Lekin yeh badam aye hain, log kehte hain isse dimag badhta hai. Mera to pahle se hi bahut badha hua hai, yeh tum sab baant ke kha lena* (Soldiers, pay attention. As you know, the army is not about using brains. We just have to shoot straight at the enemy. We have received these almonds; people say almonds are good for your brain. My brain is active enough, you guys can distribute and eat these).'

One of the main responsibilities of a company commander is to keep things light. Humour and the personal touch always work like magic in making the unit more cohesive and that is what happened here too as the gathered jawans started to shout, 'Company commander *ki jai*, company commander *ki jai*.'

In March 1959, the Chinese army that had forcibly occupied Tibet sent the twenty-three-year-old Dalai Lama an invitation to watch a dance performance by a Chinese dance troupe at their military headquarters in Lhasa. The invitation also stated that he should not be accompanied by any of his security staff and arrive all by himself. The Tibetans saw through the Chinese ploy to abduct or harm their spiritual leader and discouraged him from going to the military headquarters. One night, thereafter, on the advice of his staff and dressed in a worn-out soldier's uniform, the Dalai Lama escaped his palace in Lhasa. He was accompanied by his mother, his sister, his brother and several top Tibetan officials. They walked for two days and two nights without stopping, through the frigid and difficult mountainous terrain. Their barest belongings and one-month-long supply of food were loaded on mules that followed them. The Chinese realized two days later that the Dalai Lama had escaped and started searching all the routes that led to India. But the Dalai Lama's escape had been planned through a more difficult route. The Dalai Lama and all other escapees continued their journey and crossed the Brahmaputra River using a boat made of yak skin. On arrival in India, after a two-week journey, the Dalai Lama and his entourage applied for refugee status at a small outpost belonging to the Assam Rifles at Chutangmu

near Tawang in Arunachal Pradesh (then called NEFA or the North Eastern Frontier Agency). On 3 April 1959, Prime Minister Jawaharlal Nehru's government granted asylum to the Dalai Lama and others. The Tibetans were also granted permission to establish a government-in-exile in the hill station of Dharamshala in Himachal Pradesh (then a part of Punjab).

6

6 November 1962, Maggar Hill, Ladakh

The brigade commander visits Maggar Hill. His visit is followed by another by Lt Col H.S. Dhingra the next morning when the CO bestows an on-the-spot promotion on Capt. Jatar, making him a field major. By 11 November 1962, all posts are ready and the Charlie Company is in high spirits even though they are aware of their lack of better arms to defend the area. In platoon 7, Nk Gulab Singh and L/Nk Singh Ram, along with others, are ready and raring to go. Maj. Shaitan Singh has been regularly in touch by radio with the company commanders of Alpha, Bravo and Delta Companies. Meanwhile, information reaches them that the CO will address the entire company on the next day.

Capt. Raghunath V. Jatar was waiting to receive the brigade commander at Maggar Hill. This was a big moment for the young officer. He had heard a lot about Brig. T.N. Raina, the commander of the 114 Brigade that was tasked to defend the Chushul sector.

The post was ready in all respects for the visit. While Capt. Hari Singh Chauhan was in command of the Bravo Company, Capt. Raghunath V. Jatar was the overall post commander of Maggar Hill, with both Bravo and Delta Companies being under him.

Brig. T.N. Raina was accompanied by Lt Col H.S. Dhingra, CO, 13 Kumaon Battalion, and Captain D.D. Saklani, adjutant, 13 Kumaon.

The operational readiness review, specifically the positioning of platoons and posts, was carried out and it was appreciated by the brigade commander. After that, a *barakhana* was organized and the brigade commander addressed the jawans, JCOs and the officers present. The visit went off smoothly.

The brigade commander left Maggar Hill after expressing his satisfaction to the post commander and the CO. This was a morale booster for the Bravo and Delta Companies. The CO called Capt. Jatar the same evening after reaching Chushul, 'Good job done, captain.'

'Thank you, sir.'

Even before the CO said it, the captain knew there was something amiss. He waited, holding his breath, the telephone receiver pressed tightly against his ear.

'I have a few observations which I want you to fix immediately. I didn't want to say it in front of the brigade commander.'

'Yes, sir.'

'I also don't want to spell them out on the telephone, as there is always a chance of a communication gap. I will be there tomorrow at eleven. Ask all platoons and sections of both the companies to be ready. I will speak my mind right there.'

'Roger, sir.'

The CO, therefore, paid another visit the next morning.

Capt. Raghunath V. Jatar had no idea that this visit was going to be a special one for him. The CO had something altogether different on his mind.

In addition to his usual entourage of the adjutant and two JCOs, this time the CO was also accompanied by a sepoy from the waiter trade (now called steward). This was surprising, as the CO was not expected to stay for long and the companies were capable of meeting the working hospitality requirements from their available resources.

After the rounds that went right up to the extremities of the platoons and section posts, an operational briefing was conducted. The CO was satisfied with the overall deployment of the jawans and the siting of the weapons. He, however, instructed a few minor changes just as he had mentioned and these were duly noted by the post commander.

Then the CO settled down in the company headquarters and said, 'So, Capt. Jatar, are you ready to fight this battle as the post commander?'

It was an unusual question and the anticipation about what was going to come next grew.

'Yes, sir, of course,' came the officer's confident reply.

That's when the CO turned towards the waiter and nodded. The waiter placed four glasses on the camp table. These had a dark-coloured liquid in them and everyone realized what it was, even before the strong smell reached their nostrils. It was the favourite of the Indian Army—Old Monk Rum.

Gradually, it was becoming clearer to everyone present what was going to happen next. But all waited with halted breath as

the CO now nodded to the adjutant who pulled out an envelope from his pocket.

The CO took the envelope, opened it and gently took out a major's epaulettes from it. Then he declared, 'Captain Raghunath V. Jatar, I promote you to the rank of a field major right now.'

With that, the CO removed the captain's rank from the officer's shoulder, dipped the major's epaulettes in a glass of Old Monk and slipped the new rank on the officer's shoulders. The CO, in one instant, had granted an on-the-spot promotion of field major to the post commander of Maggar Hill.

Thereafter, all officers present picked up the glasses and said, 'Congratulations,' followed by 'Cheers!'

This was a big surprise for the officer and it inflated his chest with pride. After a few sips, the CO said, 'Congratulations, Major Jatar. Now I want to tell you that, with promotion, comes additional responsibilities.'

'Yes, sir.'

After a few more instructions and some typically fauzi banter, the CO and his entourage left Maggar Hill.

* * *

10 November 1962, Rezang La, Ladakh

By now, the posts of company headquarters, the three platoon headquarters, along with three respective sections each and the 3-inch mortar section had been firmly established. The hard work of the jawans under the three platoon commanders and the leadership of Maj. Shaitan Singh had yielded positive results.

There were a few things lacking though, and these would hurt the Charlie Company during the impending battle. These included the approaches to Rezang La which had not been mined, non-availability of RCLs and lack of artillery support. While the first two were known to the Charlie Company, the fact that the artillery support would not be available was not yet known.

One would imagine that these lapses on the part of the brigade and battalion were inexcusable. But this was not the case. One of the reasons for taking the Rezang La post for granted was because, according to the brigade's appreciation, as mentioned earlier, the attack was unlikely to come from that direction. Further, the resources available with the brigade were not enough to make the entire 40-km front impenetrable. The transport aircrafts were indeed flying in daily to Chushul airfield to augment war supplies, but maintaining and arming an entire brigade only by air, on an airstrip that needed to be repaired each time an aircraft landed, was a gargantuan task to say the least. The real fact which was hurting the Indian defence hard was the non-availability of road infrastructure in the area. The BRO was working as hard and as fast it could, but it was founded only a little over two years earlier on 7 May 1960.

In Rezang La Pass area, since the digging had been completed, the soldiers were now manning their allocated posts. Section one of platoon 7, which was located 175 yards east of the platoon headquarters, with section two 125 yards behind it, was ready in all respects too.

Here, L/Nk Singh Ram, the commander of the platoon's 2-inch mortar section that had been sited just 50 yards to its rear, was at his station. Six-feet-two-inches tall, Singh Ram was a wrestler, a boxer and a tug-of-war champion member, who was the flagbearer of the company at all major sporting events.

At two that afternoon, just after lunch, Singh Ram emerged from the trench of his mortar section and walked towards section post one where Nk Gulab Singh and two other sepoys were stationed. Though the temperature was around minus 5 degrees Celsius, it was the warmest period of the day.

Gulab Singh, the section commander of section one, smiled on seeing Singh Ram, who was also related to him, 'Singh Ram, welcome to our section. How is our wrestler feeling today?'

Singh Ram smiled, jumped into the trench and said, 'I'm fine, sir.'

Though elder to Gulab Singh by ten years, he always made it a point to acknowledge the fact that Gulab Singh was senior to him in rank.

There was a kerosene wick stove in the trench which was keeping the section post warm. One of the sepoys pushed the stove closer to Singh Ram, their visitor.

Gulab Singh nodded and asked, 'Only fine?'

Singh Ram inflated his chest and remarked, 'Fighting fit, sir!'

Gulab Singh smiled and asked, 'Tea?'

As Singh Ram nodded, Gulab Singh signalled to one of the sepoys who picked up a thermos. Two half-filled mugs were handed over to them moments later.

Singh Ram took a sip and Gulab Singh asked him, 'How is Ram Kumar?'

Sep. Ram Kumar, Singh Ram's brother, was deployed in platoon 9. Singh Ram was very close to his younger brother and took special care of him.

He removed his snow goggles, wiped the moisture that had settled on it when he had taken a sip of the tea and said, 'He is okay. I mean, he is also fighting fit.'

Gulab Singh inhaled deeply, smiled and said, 'Great! Our entire company is fighting fit, right from major sahab to each and every soldier.'

They were quiet for a while as they looked out of the trench towards the ridge that was right in front of them.

Gulab Singh spoke finally, 'Listening to the news on the radio, it appears that the Chinese don't want to peacefully solve the border dispute.'

A man of few words, Singh Ram replied, 'Hmm.'

Then, Singh Ram turned to look at Gulab Singh and asked, 'How is Sharbati? Got any letters?'

Sharbati was the name of Gulab Singh's wife. His eyes turned glassy for a few moments, but then he smiled and said, 'No.'

'Is she still in Ambala or has she returned to village Manethi?'

'I don't know. When we were in Baramulla, she was in Ambala. From Leh too, I came to know that she was still there.'

'She is now in her ninth month, and I am certain we will receive the good news soon.'

Gulab Singh smiled faintly, 'The delivery should go smoothly; that's all I'm praying for.'

'All will be well, sir.'

The two of them, however, did not know that Sharbati had already given birth to a boy and she had written a letter to Gulab Singh with the good news. Gulab Singh would never get to see this letter though, as he and Singh Ram were just days away from laying down their lives for the nation. But these two brave soldiers would not die an ordinary death. They would inflict so much damage by their planning, courage and tactics, that the 1:10-strong Chinese attack would be blunted adequately and the enemy would not dare to cross Rezang La after that.

At that moment though, at the company headquarters, 3 km to the south of where Nk Gulab Singh and L/Nk Singh Ram were talking, Maj. Shaitan Singh was reading the Battalion Routine Order (BRO) they had just received over the radio set. The radio operator, who had decrypted the coded document, was standing next to the company commander.

The most important information in the BRO was that the battalion CO, Lt Col H.S. Dhingra, was scheduled to address the troops at 10 a.m. the next day. This information was required to be passed to all the platoon commanders. As it was not possible for all the troops to listen to the address at the same location, he turned towards the radio operator and said, 'Call the CHM.'

'Yes, sir.' With this, the radio operator left the company headquarters.

As he waited, his mind was on the preparedness of the company. He knew that the boys had worked very hard. While he had selected the platoon positions well, the platoon commanders, who were experienced JCOs, had sited their weapons by the rulebook. By now, the young recruits who had arrived from Ranikhet were feeling better too. In a few more days, he imagined, they would be fit to pick up guns and fight. But, in the core of his heart, he knew that a lot was still desired if they had to stop a Chinese attack. Chushul was vulnerable and if the Charlie Company was run over, the airstrip, and because of it the whole of Ladakh region, would be lost forever.

He knew if they were attacked, most of them would perish. This was acceptable, but allowing the Chinese to move an inch ahead of Rezang La was not. The company was tough, well-trained, organically motivated, and a cohesive force made up of flesh, blood, bones and *jazba* for the motherland. And above all, their ethos was *naam, namak, nishan* which calls upon every

Indian soldier to strive for the good name of his country, the salt that he has partaken, and uphold the glory of the national flag. Each and every member of the Charlie Company was, therefore, motivated enough to make the supreme sacrifice when required.

CHM Harphul Singh arrived a few minutes later, '*Ram Ram, sahab.*'

'*Ram Ram*, Harphul. Tomorrow at ten in the morning, the CO will address the company over the radio. I want maximum soldiers to listen to the address. Clear?'

'Yes, sir.'

After a smart salute, CHM Harphul was gone.

Then, the major asked the radio operator to convey the message to all the three platoon headquarters by radio.

Maj. Shaitan Singh thought the need of the CO to address the troops right at their stations meant that there were developments underfoot. One of the reasons could be the stalemate reached by the two governments to resolve the boundary issue politically. And this obviously meant more attacks by the Chinese.

During the preceding days, Maj. Shaitan Singh had been conducting regular *milaaps* with the company commanders of Alpha, Bravo and Delta companies. Milaap meant talking to them at a pre-determined time over the radio to share information that had a direct bearing on mutual preparedness. He knew, therefore, that the situation on ground had not changed much. The Chinese build-up north of Pangong Tso Lake had been continuous, but south of Spanggur Gap, it was nominal. This corroborated with the intelligence collected by the LPs and OPs of the Charlie Company too.

In the headquarters of platoon 9, Sep. Ram Kumar, brother of L/Nk Singh Ram was thinking about his family back in

his village Dhawana in Rewari district of Haryana. Married to Bhanti Devi, sister of Singh Ram's wife, Rampyari Devi, he was not comfortable with the fact that his brother was in platoon 7, whereas he was in platoon 9. When the time came, he wanted to fight the enemy standing shoulder to shoulder with his big brother.

General Zorawar Singh, the military commander of Raja Gulab Singh of Jammu, attacked Tibet in May 1841. Known as the Napoleon of the East, Gen. Zorawar Singh by then had conquered Ladakh and Baltistan, thereby breaking the centuries-old monopoly of the Ladakhis and Kashmiris on the Tibetan trade. Jammu, at the time, was under the suzerainty of the Sikh empire. Gen. Zorawar Singh led 4000 men consisting predominantly of Dogras, but also Ladakhis, Baltis and Kishtwaris. The attackers had guns and cannons, whereas the Tibetan forces, which were 6000 strong, had only bows, swords and spears. The Sikh forces succeeded in defeating the Tibetan forces right up to Gartok and Taklakot Fort near the Nepal border. Meanwhile, Lhasa dispatched a larger contingent and, taking advantage of winters and the Sikhs' overstretched supply line, they killed Gen. Zorawar Singh in battle. The Tibetan forces then continued westwards and attacked Ladakh. But by then, Raja Gulab Singh had dispatched more forces from Jammu and the Tibetans were defeated. So impressed were the Tibetans by the valour of Gen. Zorawar Singh that they buried him with full military honours on a hill close to Taklakot Fort, where the memorial, or the *samadhi* as it is called, continues to stand to this day.

7

11 November 1962, Rezang La

The CO's address over the radio followed by the company commander's address fills the jawans of Charlie Company with palpable josh. Meanwhile, the brigade commander reviews the preparations and sends information to the Charlie Company through the CO that, after China attacks, they can withdraw if the situation becomes untenable. Maj. Shaitan Singh consults the jawans of his company through his three platoon commanders and they say that they will fight till the last man and the last bullet. The company commander and the CO support the jawans' stand and relay the same message to the brigade commander. The cohesion between the jawans and their resolve to fight it out till the very end becomes clearer as their conversations at various posts reveal.

11 November 1962 was a Sunday, but the preparations for listening to the CO's address had been made. Except for one soldier in each trench and the LPs and OPs, all the others had gathered in the three platoon headquarters in addition to

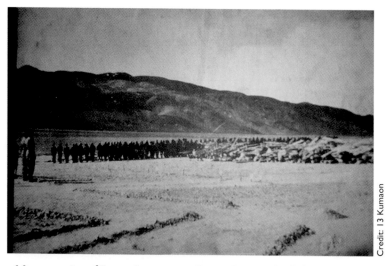

Mass cremation of Rezang La martyrs at Rezang La near Chushul in Ladakh in February 1963.

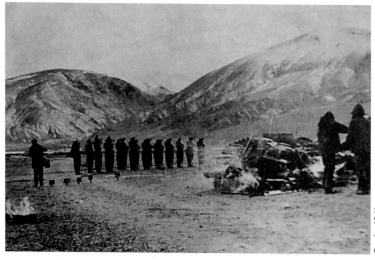

Cremation of martyrs at Rezang La in February 1963.

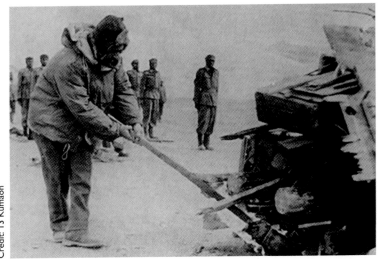

Brig. T.N. Raina, MVC, Commander of the 114 Infantry Brigade, lights the funeral pyre of the martyrs of the battle of Rezang La in February 1963.

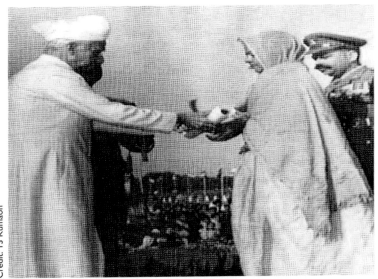

Mrs Shaitan Singh receiving the Param Vir Chakra from Dr Rajendra Prasad, President of India, on behalf of Maj. Shaitan Singh.

Original war diary of the 13 Kumaon Battalion as shared by 13 Kumaon with the author in December 2020.

WATER BOTTLE
NK GULAB SINGH, VrC

Water bottle used by Nk Gulab Singh, Vir Chakra, during the war as preserved at the Rezang La museum, co-located with 13 Kumaon.

SOAP CASE
JEM HARI RAM,

Soap case of Jemadar (now called Naib Subedar) Hari Ram,
Vir Chakra, retrieved from the battleground and as preserved
at the Rezang La museum, co-located with 13 Kumaon.

THESE BUGLES CRIED THE LAST POST IN FEB 1963
IN HONOUR OF THE 96 OF THE 114 VEER AHIRS AT CHUSHUL

The original bugles that cried the last post in February 1963, which adorn the
wall of the Rezang La museum, co-located with 13 Kumaon.

Sep. (retired as Hav.) Nihal Singh, Sena Medal, at his village in December 2020.

Son of L/Nk Singh Ram, Vir Chakra, holding his father's portrait, December 2020.

Author with the wife of Nk Gulab Singh, Vir Chakra, and her son, December 2020.

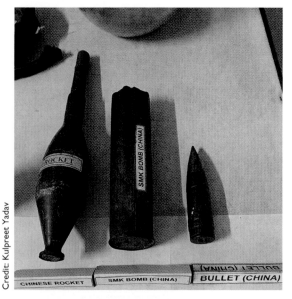

Some of the Chinese bombs recovered from Rezang La as displayed
at the Rezang La museum, co-located with 13 Kumaon.

13 Kumaon is now officially called the Rezang La Battalion.

Credit: Kulpreet Yadav

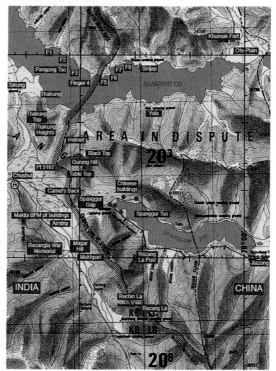

Map including Rezang La, Rechin La and their valleys leading to the Spanggur Lake.

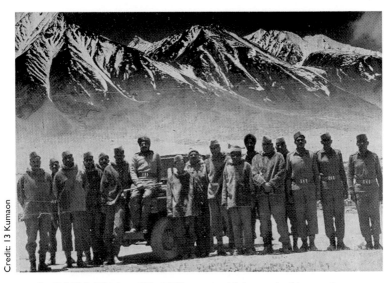

Credit: 13 Kumaon

Lt Col H.S. Dhingra, CO, 13 Kumaon, with jawans in this rare picture, days before the war.

Credit: Kulpreet Yadav

The author with Hon. Capt. Ram Chander, Vir Chakra, platoon commander, platoon 9, 13 Kumaon, who survived the 1962 war. This picture was taken at his village in January 2021. Hon. Capt. Ram Chander passed away in March 2021.

the company headquarters. The time was half past nine in the morning and the radio operators were busy adjusting the volume and squelch of the communication sets. Loudspeakers were kept ready next to these sets so that the voice could be carried to a maximum distance.

At sharp 10 a.m., the CO's voice boomed on the set, '*13 Kumaon ke bahadur yoddhaon, ab woh din door nahin hai jiska har fauji intezaar karta hai. Bahut se log bagair ladai lade hi retire ho jate hain. Lekin kuch chune hue logo ko Bharat mata apni raksha karne ka mauka deti hai. Is baar Bharat mata ne apni izzat ki raksha ke liye hamein chuna hai. Hamne apne josh aur bahaduri ka parichay kai baar diya hai, lekin, iss baar dushman naya hai. Cheen soch raha hai ke jaise 20 October ko usne hamare saath daga baazi se hamari zameen chheen li hai, waise hi woh ab Chushul bhi chheen lega. Lekin usse pata nahi hai ke yahan kaun baitha hai. 13 Kumaon ke bahaduron, dushman ko sabak sikhane ka samay aa gaya hai. Hamare Ahir jawan, jinke purwajon ne 1857 main angrezon ke daant khatte kiye the, unhi ka khoon aap sab ke ragoon mein daud raha hai. Cheen ko hamare bare mein abhi pata nahin hai. Agar woh iss taraf aankh utha kar bhi dekhega, to hum uski aankh nikal lenge. Agar woh iss taraf attack karne ke liye aata hai, to hum usko khatam kar denge. Yeh Bharat mata ki dharti hai. Hum iss battlefield ko Cheen ki sabse badi galti saabit karke hi dum lenge. Bahaduron, hum last man last bullet tak ladenge. Jai Hind*! (Brave soldiers of 13 Kumaon, the day that every soldier waits for is not far now. Many people retire from the army without fighting a war. But only a handful of people get an opportunity to protect our motherland. This time our motherland has selected us to protect her honour. We have proved our bravery many times, but this time we are fighting a new enemy. China is thinking, just as they tricked us on

20 October and stole our land, they can now steal Chushul too. But they have no idea who is waiting for them here. Brave soldiers of 13 Kumaon, the time has come to teach the enemy a lesson. My Ahir soldiers, you have the same blood running in your veins as your ancestors who had fought with the British in 1857. China doesn't know about us at the moment. If they lift their eyes and stare at us, we will pluck out their eyes. If they choose to attack us, we will erase them. This is Indian land. We will prove this attack to be China's biggest mistake. Brave soldiers, we will fight till the last man, last bullet. Jai Hind!)'

The CO's address filled the troops with palpable josh. It was a sight to see that, after listening to this message, all the jawans were visibly charged. For Maj. Shaitan Singh, a reply was in order. After the CO's motivating address, it was the company commander's turn to motivate his direct command. He nodded to the radio operator who picked up the transmitter again, pressed the transmit switch and moved the mouthpiece closer to the major's mouth.

'*Charlie Company ke bahadur jawano, jaisa CO sahab ne kaha hai, yeh hamari khushkismati hai ki hamein yahan Bharat mata ki hifazat ke liye bheja gaya hai. Aapko pata hai ki aaj desh mein har ek mard border pe jaan dene ke liye taiyyaar hai. Recruitment centres par bheed lagi hui hain. Har aadmi China ko sabak sikhana chahta hai. Lekin sachh yeh hai ki yeh mauka hamare ko mila hai . . . Maine khud aapki tayyari dekhi hai. Ek ek jawan ne apni poori taakat ke saath yeh morchhe banaye hai. Hamari champion company dushman ko dikha degi ki Bharat mata ke beton mein kitna dum hai. Jeet ya veergati, hamare paas do hi raaste hain. Mujhe poora vishwaas hai ki Charlie Company ke bahadur jawaan dushman ke chakke chudaa denge. Jai Hind*! (Brave soldiers of the Charlie Company, as our CO has said, we

are fortunate that we have been sent here to protect the honour of Mother India. As you know, today in India every young man is ready to come to the border and fight. Recruitment centres are flooded with volunteers. Each Indian wants to teach China a lesson. But the truth is, we have got this opportunity. I have been a witness to your preparations. Every soldier has worked very hard to prepare these defence positions. Our champion company will show the enemy how brave are the sons of Mother India. Victory or martyrdom, we have only two options. I'm confident that the brave soldiers of the Charlie Company will wipe out the enemy. Jai Hind!)'

Inside the headquarters of platoon 8, Naib Subedar Hari Ram looked at the taut faces of the soldiers of his platoon who were listening with rapt attention. Hailing from Santaur village of Buhana tehsil in Jhunjhunu district, Hari Ram was a hard taskmaster whom the entire platoon had immense respect for. It was a well-known fact that in case of an attack, platoon 8 would face the onslaught first, both artillery and attack by the enemy's infantry. Being right in the middle of the pass, the section's weapons were tactically sited, with 150 yards distance between them and covering the entire passage as best as possible with overlapping firing arcs.

Hari Ram had deployed his best soldiers, Nk Hukum Chand, Hav. Ram Anand and Nk Chandagi Ram as section commanders of sections one, two and three respectively.

After listening to the josh talk by the CO and the company commander, a fully charged Nk Hukum Chand got up and saluted Hari Ram. Then he left for section one located approximately 300 yards to the east of the platoon headquarters in the direction of the mouth of the pass. He was followed by a sepoy from his section.

Nk Hukum Chand and the sepoy who followed him joined the solitary sepoy who was looking out from the trench, his rifle pointed towards the east. Hukum Chand passed on to this section-mate what the CO and the company commander had said moments ago.

Twenty-nine years old, Hukum Chand was five-feet-nine-inches tall. He was a good hockey player. Father of three children, his son Ram Kishen was eight years old and his daughters, Savitri and Angoori, were two years and a few months old respectively.

After some time, they saw someone approach them from behind. It was Sep. Dharampal Dahiya (nursing assistant). Jovial and hardworking, Sep. Dharampal was the lifeline of the company. In the absence of a doctor, he dispensed the routine medicines and was good at diagnosis. Because of his professionalism, the medical stores with the company were optimal.

'Dharampal, come on, join us.'

Dharampal lowered himself into the trench.

'Missing Sonipat?' Hukum Chand asked him.

'More than Sonipat, I'm missing Nirthan, sir.'

Hukum Chand knew Nirthan was Dharampal's village in Sonipat district of Haryana.

'How is Vidhyawati? Got any letters from home?' Vidhyawati was the name of Dharampal's wife who lived in his village.

'She is fine, sir. I had got a letter too.'

'Dharampal, we have only one medical assistant but three platoons, and that too three kilometres from one another. In case of an attack, how will you manage? Thought about it?'

'Sir, I will go to each and every post and do my work. Let the jawans focus on their guns, I will always be ready with my bandages and injections.'

The terrain around them was blindingly white and desolate as always. Since the Rezang La Pass was above the treeline, the mountains, ridges, spurs, knolls, rocks, even their bunkers were all covered in white and it was getting harder for the company to handle the falling snow as the quantity of precipitation was increasing by the day. Even though they were informed that Ladakh was in a rain shadow area and received very little rainfall or snow, the winter of 1962 certainly had different plans.

The sighting of an animal at this altitude was rare now, but they did spot birds sometimes. With the winter properly set in, even the wildlife had chosen to abandon the area. The week they had arrived though, they had spotted bharals (blue sheep), Asiatic ibex and the Himalayan marmots (ground squirrels). The soldiers were looking forward to seeing the majestic snow leopard too, but the sight had eluded them so far.

Meanwhile, in the company headquarters, Maj. Shaitan Singh's thoughts were on his company's defences. Even though he had deployed all his troops to cover the area allotted to the company and sited his weapons well, he knew in his heart that if the Chinese attacked them in numerical superiority and with the advanced weapons that they possessed, the company would have no option but to fight it out till the last man, last bullet. The only way, he thought, they had a small chance of saving the area was if the artillery firing from the base was accurate and other battalions backed his company up with more troops as reinforcements.

He called Nk Ram Kumar and asked him, 'Ram Kumar, how many 3-inch mortar bombs have you prepared?'

Nk Ram Kumar gave the company commander a smart salute and said, 'Sir, 1000 bombs.'

'That's good, but let's place a demand for more.'

'Yes, sir.'

There was another thing that was troubling him. Due to the intense cold that they were experiencing now, it would be impossible for the jawans to fire their guns with exposed fingers. And if the jawans kept wearing their woollen gloves, their fingers would not get inside the trigger guard. Firing a few rounds was still possible using bare fingers, but sustained firing and prolonged contact with the metal trigger would cause cold burns on the fingers. In fact, the fingers would get fused to the metal due to the cold.

The words spoken by the CO were still ringing in his ears. With each passing moment, he could sense the danger creeping in. Maj. Shaitan Singh had been in touch with the post commanders of the B and D Companies, Maj. Jatar, and with the company commander of A Company, Maj. G.N. Sinha. The situation on ground, therefore, was known to him.

Meanwhile, 1/8 Gorkha Rifles and 1 Jat LI had spotted the reconnaissance visits of Chinese army commanders in the Spanggur Gap area on the Chinese side of the border. These Chinese officers were accompanied by troops who would lay out maps and point fingers at the locations of the Indian posts. It was all happening in plain sight.

At the brigade headquarters in Chushul, Brig. T.N. Raina was also aware of these developments and he had taken all possible steps. Six AMX-13 tanks that were flown in by AN-12 aircrafts were now ready with their turrets pointing towards the enemy. The Indian soldiers had mined the Spanggur Gap area too with anti-tank mines, keeping in mind every tankable approach and had additionally covered it by 106 mm RCL guns. While the field artillery and armour were hidden under cover, dummy guns and dummy fuel tanks were set up to mislead the enemy.

In addition, a few old and disused bulldozers were made to look like tanks. With a well-thought deception plan and meticulous preparations, the Indians awaited the Chinese attack.

By now, Brig. T.N. Raina was in the best position military-preparedness-wise. All the penny pickets, comprising a handful of soldiers and deployed in the remote and indefensible areas connected only by mule tracks on the advice of the Intelligence Bureau (IB), were no longer existing. Although the Indians had paid a heavy price in the first phase of the battle between 20 October 1962 and 24 October 1962, the situation was much better now. It was going to be difficult for the Chinese to make the misadventure of approaching Chushul through the Spanggur Gap.

At that time, the Chinese did have Black Top Hill with them, which was higher than both Gurung Hill and Maggar Hill, but to launch an infantry attack from there, they would have to climb down and make a charge in the open. This would make them sitting ducks for the Indian RCLs, tank ammunition, mortars, 25-pounder artillery guns, MMGs, LMGs and finally, the rifles. In addition, the approach had been mined too.

The brigade commander's only worry at that time was the Rezang La post. Not only was the post isolated, at least one of its platoons was deployed in the open. In addition, to give them artillery support, the positions of the guns would also have to be adjusted so that the hill feature in-between didn't block the trajectory of the bombs.

The logical step ahead to safeguard the position, therefore, was to put up a fight, but if the heat got too much, the Charlie Company would have to move back.

With this in mind, he called up Lt Col H.S. Dhingra, 'Colonel Dhingra, is everything okay?'

'Yes, sir. Everything is under control.'

'Look, our position in Rezang La is vulnerable. The boys have no back-up and have limited firepower.'

'Yes, sir. But we are ready to take on the enemy.'

'You sure are, colonel! I know that you had commanded the Charlie Company in the past and you know the boys well. But what I want them to do is to slow down the enemy from that side and if it becomes impossible to defend Rezang La, they should plan an organized retreat.'

There was a pause. On the CO's mind was the address he had given to the Charlie Company just the day before. But, being an upright officer, he replied, 'Roger, sir.'

The message of the brigade commander was conveyed by the CO personally to Maj. Shaitan Singh on the telephone moments later, 'Major, how is everything?'

'All okay, sir.'

'Brigade commander has said that the Charlie Company should put up a stiff resistance if they are attacked, but can fall back if it becomes unsustainable. It's your call, major.'

Maj. Shaitan Singh, being an inclusive officer who respected and admired the experience and seniority of his JCOs, said, 'Right, sir. But I need to discuss this with my platoon commanders.'

'Sure, do that.'

After putting the phone down, Maj. Shaitan Singh walked down to platoon 8 and called the senior JCO of the Charlie Company, Naib Subedar Hari Ram.

Hari Ram came and saluted the company commander.

'Hari Ram sahab, brigade commander has said if the war indeed breaks out and we start losing, then we must retreat.'

The commander of platoon 8 hesitated and said, 'Sir, can I consult my jawans about what they want?'

In any army of the world, in those days, this was unusual. Orders were followed without question, but this is where the Charlie Company was different. The company commander, Maj. Shaitan Singh, was decades ahead of his time.

'Yes, please ask them. Also, as the seniormost JCO of the company, I want you to coordinate the response from the other platoons too.'

As soon as the word spread within the platoons, a discussion started between the jawans. It went along these lines.

One jawan said, '*Yeh one hundred per cent Ahir infantry unit hai* (This is a one hundred per cent Ahir company).'

Another added, '*1857 mein, Narnaul ki ladai mein, joh pehli azaadi ki ladai ka hissa thi, Ahir jawano ne 70 angrez soldiers aur unke commanders, Colonel Gerrard aur Captain Wallace ko maar giraya tha* (In 1857, during the battle of Narnaul, which was a part of the first battle of Indian independence, Ahir soldiers had killed seventy British soldiers including their commanders, Colonel Gerrard and Captain Wallace).'

The third one reasoned, '*Hum Narnaul jaisi ladai ladenge* (We will fight like the battle of Narnaul).'

There was a pause after which a jawan said, '*Jaisa CO sahab ne kaha, dushman ko pata nahi hai ki yahan kaun baitha hai* (As CO sahab has said, the enemy doesn't have any idea who's waiting for them here).'

Finally, everyone shouted in chorus, '*Dada Kishan ki jai.*'

On 21 July 1959, based on a decision of the army, the 13 Kumaon Battalion had been turned into a 100 per cent Ahir battalion and an entry to this effect was made into the war diary of the battalion. On the same day, other battalions of the Kumaon Regiment were also converted either as 100 per cent

Ahir or as 100 per cent Kumaoni battalions, while a few were allowed to retain their mixed composition.

After the decision of the soldiers was conveyed to him that they would not move back even one inch, Naib Subedar Hari Ram addressed them, 'I agree with you. We will fight till our last breath. But now I want you to listen to me carefully . . .'

There was pin-drop silence among the jawans as they waited.

He continued, 'After this decision, if anyone turns his back during the battle when China attacks us, even before the enemy can kill him, I will kill him myself.' He paused, letting this settle and then added, 'And if I turn my back, I authorize you to kill me.'

All eyes were on Hari Ram now and his eyes were on them. The pact had been made.

After this, Naib Subedar Hari Ram went to the company commander. He saluted and said, 'Sir, the company has decided that we will not move behind even one inch. I recommend this and request you to approve it.'

Maj. Shaitan Singh, the true soldier's soldier, nodded and replied, 'Yes, this is what I had expected from my champion company.'

With this, as Naib Subedar Hari Ram saluted again and left, Maj. Shaitan Singh reached out to the telephone. Within minutes, he was conveying his decision to the CO, 'Sir, the Charlie Company will hold the post till the last man and last bullet.'

These were precisely the CO's original orders and being the company commander of the Charlie Company earlier, he was satisfied.

'Excellent!' That's all he said before conveying the decision to the brigade commander.

The battle of Narnaul was fought between the British Raj and the combined Indian forces led by Rao Tula Ram, the Ahir ruler of Rewari, on 16 November 1857 at Nasibpur near Narnaul city located in modern-day Haryana. It was one of the fiercest battles of the first war of independence in which seventy British soldiers were killed including their commanders, Colonel I.G. Gerrard and Captain Wallace. Hundreds of Indians were killed too. The British troops were 3000 while the Indian patriots were 5000. Lt Col George Bruce Malleson, one of the British officers, later wrote, 'It was a gallant conflict . . . never did the enemy fight better. There was neither shirking nor lurching. Never was there a charge more gallant and certainly never were the British cavalry met so fully or in so full a swing by the rebel horse.' In the end, due to superior artillery, the British forces won the battle. With the end of the battle, the vengeance of the victors started. A large number of persons from Rewari and Narnaul were arrested and penalized for sympathizing with the rebels and the estates of Rao Tula Ram, Rao Gopal Dev and other Ahir leaders were confiscated.

8

17 November 1962, Observation Post, Rezang La Pass, Ladakh

The jawans manning the observation post (OP) ahead of platoon 7 report the arrival of a large number of Chinese soldiers in vehicles. Dozens of armoured vehicles towing big artillery guns are spotted too. At night, Maj. Shaitan Singh receives a call from the battalion's adjutant, the call that would be his last to anyone outside his company. At 2 a.m., Chinese soldiers are spotted by the listening post (LP) of platoon 8. After their intentions are clear that they are indeed coming to attack, the Indians, under the leadership of Nk Hukum Chand, engage them and warn the entire company. The jawans rush to their action posts and get into positions to defend the Indian territory as the Chinese fire artillery and carry out their first infantry attack.

It was eight in the morning. 'Soldier one' of the OP of platoon 7, who was sitting idly on a vantage point along with 'soldier two', removed his left glove, and adjusted the focusing thumbwheel of the binoculars he was looking through. Something

had caught his eye. There was movement on the white desert of the Ladakh–Tibet border that was spread out before him.

He was one of the four alert sepoys selected and groomed by Naib Subedar Surja Ram for observation tasks. Soldier two was seated next to him, holding a radio set. Near his boots, a small notebook was kept. In this notebook, the two of them logged their daily OP sightings.

They had arrived in this position, around a mile ahead of their platoon, in the morning at seven for a twelve-hour watch. The two soldiers they had replaced would now be back at seven in the evening and so it would continue on rotation.

The sun was bright and the air as rare as it had been these past few weeks. It was a mundane job, but both knew intelligence collected through careful observation, along with the intelligence collected by the OPs of platoons 8 and 9, would play a vital role in the result of the war.

Soldier one whispered, 'I can see some movement.'

With this, he zoomed in that direction and adjusted the focus of the binoculars for a better view.

Soldier two straightened his back and picked up his notebook. He asked, his voice hushed, 'What is it?'

'Vehicles . . . I can see vehicles coming from Rudok side.'

'Can you count them?'

'Can't see clearly as the tops of the vehicles seem camouflaged, but these sure are vehicles and they are moving in one line. One, two, three . . . '

He counted up to thirty-two vehicles. The other soldier started logging it in the notebook.

The vehicles stopped on the Chinese side of the border and soldiers started to get down. They looked tiny from this far and their snow camouflage was good.

Due to the discomfort, soldier one removed his fingers from the focusing thumbwheel of the binoculars he was slowly turning. When handling the binoculars, every few seconds, he had to do this, otherwise his fingers could fuse with the cold metal. He put his gloves back on and handed over the binoculars to soldier two.

Now, soldier two removed his left-hand glove and adjusted the focusing thumbwheel on the binoculars for himself. After a minute of observation, he said, 'Right, a lot of vehicles and a lot of soldiers. These look like three-tonners. Did you count how many got down from any of the vehicles?'

Soldier one replied, 'Difficult to say accurately, but I would reckon around fifty per vehicle.'

'I can see more movement now . . . more trucks, wait a minute . . . they are towing artillery guns. Big ones.'

The two soldiers were quiet for a couple of minutes. The one looking through the binoculars finally took his eyes off and looked at his partner. Both knew what this meant.

They radioed the details. A total of thirty-two vehicles filled with soldiers, eleven big guns, nine RCLs and twenty-two smaller guns that seemed like MMGs. They were ordered to keep looking out for more.

Within seconds, Naib Subedar Surja Ram was on the radio with the company commander, Maj. Shaitan Singh. Shaitan Singh had received similar reports from the OPs of platoons 8 and 9 too. He immediately called the CO. Everyone in the chain of command knew what this meant. It was time.

Maj. Shaitan Singh then spoke to all three platoon commanders on the radio. All of them assured him that they were ready to face the enemy.

All three OPs noticed the arrival of more vehicles during the day. As night fell, the LPs were asked by the platoon commanders to be extra vigilant. The company had two layers of warning systems in place. If the enemy sneaked in without being detected by the OPs, the LPs would definitely hear them. The platoon commanders had trained their LPs well too.

The LPs had rigged cables across possible routes the enemy would take. These cables were woven through a string of empty jam tins every few feet. Though rudimentary, this was an effective and almost fail-safe way of detecting the enemy early.

* * *

Earlier during the day, i.e., on 17 November 1962, Maj. Shaitan Singh had received a letter from his home in Jodhpur. He had read and re-read the letter many times and could not help smiling. He was amused because the letter mentioned the rumours of his martyrdom.

At 7 p.m., there was a call from the battalion headquarters. The radio operator held out the receiver and said to his company commander, 'Sir, adjutant sahab is on the line.'

Maj. Shaitan Singh took the receiver and said, 'Hello, Captain Saklani, how are you?'

'Sir, good evening. I'm fine. How are things at your end?'

'So far, it's all quiet, but we are alert and fully prepared. The reports of the OPs have already been conveyed to you.'

'Yes, sir.'

With this, Maj. Shaitan Singh laughed.

'Sir?' The adjutant sounded confused.

'Captain, I am laughing because people in Jodhpur think I have already been martyred.'

'I'm sorry sir, but I don't quite understand.'

'I have received a letter from home today, captain. That's what it says.' He laughed some more.

'I'm not sure who manufactures these rumours, sir.'

'Don't worry, it happens.'

Even though he was laughing, Capt. D.D. Saklani could sense concern in his voice. The conversation stayed with him.

At ten that night, Capt. D.D. Saklani called him again. He wanted to ask Maj. Shaitan Singh if he wanted a message sent home to Jodhpur to convey that he was well. Sep. Mohinder Singh, the radio operator who received the call, said, 'Sahab has gone to his bunker to rest. Should I call him?'

Capt. D.D. Saklani thought for a second and then replied, 'It's okay, I'll speak with him tomorrow.'

First Wave of Chinese Attack, 2 a.m., 18 November 1962

On the night of 18 November 1962, the moon was in its last quarter (half-moon) and the night visibility was good. At two in the morning, the senior LP of platoon 8 L/Nk Brij Lal and his fellow soldier heard a sound. They waited with bated breath for a few seconds and then spotted dozens of Chinese soldiers scrambling through the gullies and slowly moving towards their position. The Indian LP soldiers were well-camouflaged and within a few more minutes, it was clear to them that this was not a routine Chinese patrol.

Very carefully, the LP soldiers moved back towards the platoon without making a sound. Since section one was on their way, they informed its section commander, Nk Hukum Chand

first. Hukum Chand rushed towards the platoon headquarters and informed Naib Subedar Hari Ram.

'*Sahab, dushman 30 ki nafri mein aa raha hai* (Sahab, 30 enemy soldiers are approaching in our direction).'

Naib Subedar Hari Ram, the senior JCO of the Charlie Company, handed him a Very pistol and gave him an instant order, 'Here, take this and move your LMG det to the LP position. Monitor the enemy's intentions and take action.'

'Roger, sir.'

Nk Hukum Chand rushed back to his section. From there, he picked up his LMG det, L/Nk Ram Singh, and quietly made his way to the LP's position. By now, the enemy had closed in further and they were just a few hundred yards away. Along with the LP jawans who had readied their rifles, they began to wait.

Meanwhile, in the headquarters of platoon 8, Naib Subedar Hari Ram called company commander Maj. Shaitan Singh, 'Sir, around thirty enemy soldiers are approaching our platoon.'

'Okay, I want more details.'

'Sir, I have sent the LP jawans with section one commander and his LMG det forward to assess the situation.'

'Okay. We have to be careful.'

'Yes sir, the fact is that the enemy is well within our area, but I have ordered the jawans to first understand their intentions and only then take suitable action.'

'Good. Keep me informed.'

Ahead of platoon 8, it was deathly quiet now. The Chinese were making their way forward as soundlessly as they could.

Nk Hukum Chand had two tasks once the enemy's intentions were one hundred per cent clear. One, engage them, and two, warn the entire company so that all jawans could rush to their battle positions quickly and be ready for the fight.

In a few minutes, the enemy's intentions were clear. All Chinese soldiers were seen carrying 7.62 mm self-loading rifles as they made their way straight to the company's position.

Once the enemy was around 50 yards away, Nk Hukum Chand ordered, 'Fire.'

They started firing at the group of approaching Chinese soldiers with two .303 rifles and one LMG. Simultaneously, Nk Hukum Chand fired the red flare that lit the surroundings eerily. The Chinese were caught off-guard by this hot reception. The LMG is a deadly weapon and with a belt of ammunition feeding it, within seconds, the column of enemy soldiers was brought down. The firing continued for ten minutes when Nk Hukum Chand ordered, 'Stop firing.'

Many Chinese were killed, while others ran away.

After this, Nk Hukum Chand, Nk Ram Singh and the two LP soldiers rushed back to their platoon.

Meanwhile, the company sprang into action like a well-oiled machine. The regular training and the fitness of the soldiers could be put to use now. Maj. Shaitan Singh picked up the telephone to inform the CO, but it was not working. This was surprising, because he had spoken to the adjutant, Capt. D.D. Saklani, at seven the previous evening. He ordered the operator Sep. Mohinder Singh to contact the battalion headquarters on the radio but here too, there was no response.

All section posts and mortar sections were fully manned by now and it had started to snow lightly, bringing the visibility down to around a kilometre or 1100 yards. The tightly-knit, well-trained and tactically-deployed unit was on full alert. All their personal emotions and feelings were now buried deep under an adrenaline rush. With gloved fingers on the trigger guards of their weapons, they waited.

The Chinese intrusion had come from the direction of platoon 8. Was the enemy approaching the company's position from other directions too? Maj. Shaitan Singh decided to double-check the integrity of the security perimeter of his company. He quickly assembled a patrol party comprising jawans from platoon 9 and sent them to check the position on ground. The time was 3 a.m. now. The patrol party returned half an hour later with the news that more Chinese were approaching platoon 7 and 8 simultaneously.

'How many do you think?' he asked the patrol commander.

'A large number, sir. Up to where the visibility allowed us to see, we could see only Chinese soldiers. I think they are around 400 on each side.'

Maj. Shaitan Singh understood that this was a major attack. But they were ready and he knew he could depend on his boys.

The temperature was minus 24 degrees Celsius now. Just like the focusing thumbwheel of the binoculars, and as explained earlier, since the trigger and trigger guard were made of metal, they were so cold that they would stick to the naked finger and cause cold burns. Unfortunately for the soldiers, the space within the trigger guards was not enough for the gloved fingers to get inside and squeeze the trigger. This meant that when the time came, they would have to remove the gloves and use their naked fingers to fire their weapons without worrying about their fingers.

The OP positions of all three platoons, which were ahead of the LP positions by a few hundred yards, had heard the sound of the LMG's burst and seen the red flare too. The jawans manning these positions therefore rushed back to their respective platoons. The company comprising one officer and 120 jawans was on its own now.

Maj. Shaitan Singh said to Sep. Mohinder Singh, 'You must keep calling the battalion headquarters every few minutes.'

Sep. Mohinder Singh replied, 'Roger, sir.'

In war, more than the firepower, two areas can make or break the chances of any unit from even a position of strength. The first is intelligence, and the second, communications. Therefore, Maj. Shaitan Singh knew the company's ability to communicate before the war and during the conflict was crucial to their sustainability.

Sep. Ram Chander's set was working fine. He was in constant touch with the three platoon commanders on the radio and was relaying the situation to the company commander as and when he was receiving it.

The Chinese began shelling the Charlie Company at 0335 hours. The focus of the enemy bombardment was platoon positions 7 and 8, and the 3-inch mortar section located right behind the company headquarters. The Indian troops had no option but to protect themselves from this attack by staying down in their bunkers and trenches. The shelling was heavy and continued non-stop for twenty minutes.

As soon as the shelling stopped, Maj. Shaitan Singh ordered Sep. Ram Chander, 'Check the damage from platoons 7 and 8.'

'Roger, sir.'

Within seconds, Sep. Ram Chander was relaying the information received from the three platoon commanders, 'Hardly any damage, sir. Just a few jawans injured.'

The company commander was relieved. But this was temporary. Because as soon as Sep. Ram Chander contacted Nk Ram Kumar, commander of the 3-inch mortar post, where two 3-inch mortars had been sited side by side, there was bad news waiting.

Ram Chander raised his head and looked in Maj. Shaitan Singh's direction as he relayed the message, 'Sir, one of our 3-inch mortars has taken a direct hit. The gun has been damaged and the three jawans manning it have been martyred.'

The intensity of the shelling and the diversity of the weapons used by the Chinese were an indication of the determination to take the position at any cost. To destroy bunkers, they wheelbarrowed anti-tank guns to the flanks of our (Indian) positions and fired them massively. The four-feet-deep craters found in solid rock around company headquarters were a clear indication that they even used a certain number of big rockets. The shelling was indeed a spectacular display of the Chinese at night. An officer watched it from 4 miles away. 'I saw missiles,' he later said, 'with flaming red tails falling on Rezang La. The spectacle was so weird, we thought the entire Rezang La was on fire.' Another soldier at a post 4 miles south reported, 'The explosions were so great that the walls of our cookhouse collapsed.'

Source: From the official version of 13 Kumaon Battalion.

9

18 November 1962, Rezang La Pass, 0400 hours

The Chinese army launches a full-frontal attack. As the Indians defeat their human waves, the intensity of the Chinese attack keeps increasing. The Indians, who remain resilient and mindful of their limited ammunition, engage the enemy only when they are within the range of their rifles and LMGs during the third, fourth and fifth waves of attack. Meanwhile, the 3-inch mortar, under the command of Nk Ram Kumar, coordinates accurate bombing as guided by the platoon commanders of platoons 7 and 8. Maj. Shaitan Singh keeps a close watch on the progress of the battle and tries to communicate with the CO so that he can request for artillery support and reinforcements. But there is no response on the radio and the telephone line too seems to have been damaged by the Chinese bombing.

Losing one 3-inch mortar and the jawans manning it was a jolt for Maj. Shaitan Singh for several reasons. One, he had lost three precious lives. Two, the accurate enemy fire on the 3-inch mortar's position meant that the enemy knew its exact

geographical location and they could destroy the company's second mortar gun soon too. With both 3-inch mortars gone, the company's largest weapons, the company would be left with only the nine LMGs and individual Lee Enfield .303 rifles with jawans, besides the grenades and respective 2-inch mortars with the platoons.

Maj. Shaitan Singh probably had no time to wonder how the information about the location of the mortar guns had leaked to the enemy. But, after the war, it would not be hard for the defence analysts to put two and two together. The hurried deployment of the Indian Army in Ladakh meant hiring of a large number of local yak and mule herders. Though many of these worked as information sources for the Indian Army, sensitizing them of the enemy's intentions must have been lower down on the army's list of priorities.

The build-up was at such a breakneck speed that even on 18 November 1962, the brigade was still busy organizing essential clothing, weapons, ammunitions, tanks and food. The army and the IB, therefore, had no idea that months before the war, the Chinese had infiltrated the Ladakh region and made friends with the locals. As the Indian Army hired them to transport their weapons and kit bags since there were no roads, all the compromised locals had to do was observe the situation on ground and report back to their Chinese handlers. A few dozen agreeing to do this in exchange for money would have been more than enough for China. According to analysts, many locals worked for both the sides.

For the moment, let us return to the company headquarters in Rezang La. Maj. Shaitan Singh knew that the only way to save the situation was to get on the offensive. Nk Ram Kumar, in the meantime, called and said, 'Sir, I have assembled an alternate

crew of three jawans for gun number one and even though it's been damaged, we can still use it without its sight.'

Second Wave of Chinese Attack, 4 a.m., 18 November 1962

Naib Subedar Surja Ram radioed and said, 'Sir, a column of enemy soldiers, around forty in number, are approaching through the re-entrant on our left where I had planned the alternate position for section three.'

'What's your plan, Surja sahab?'

'Sir, I have already redeployed section three to occupy this position and ordered them not to allow the enemy to pass through from there at any cost.'

This was a smaller attack, but Maj. Shaitan Singh knew a larger attack would follow soon. The report of the patrol he had sent was on his mind.

As ordered by his platoon commander, Nk Sahi Ram, along with the jawans of his section, reached the alternate position without being seen and as soon as the enemy was within 100 yards, he ordered, 'Fire.' All soldiers of his section attacked the enemy with LMGs and rifles and also threw grenades at the enemy as they tried to close in.

The second wave was defeated too as most of the Chinese soldiers died, since the line of fire was from an unexpected direction. The barrage of fire from the hidden positions of Nk Sahi Ram's section on the Chinese soldiers who were in the open completely annihilated their platoon-size attack.

Naib Subedar Surja Ram was on the radio immediately after the enemy's guns had been silenced, 'Sir, we have succeeded in stopping the enemy. It's all quiet now.'

'Well done, platoon 7. But they are hiding out of sight and regrouping right now. The next attack will be much larger, Surja sahab. Be prepared.'

'Roger, sir.'

Third Wave of Chinese Attack (from Two Sides), 4.55 a.m., 18 November 1962

Within seconds, Naib Subedar Surja Ram was back on the radio, 'Sir, I can now see a big attack forming up. The enemy is around 400 in number. I urgently need the 3-inch mortar's support.'

Even before Maj. Shaitan Singh could order his offensive, Naib Subedar Hari Ram came on the radio and informed that from his right, he could see a large number of Chinese approaching too.

This third wave was a major Chinese attack and it was absolutely necessary to repulse it.

Maj. Shaitan Singh, Naib Subedar Surja Ram and Naib Subedar Hari Ram had marked the probable enemy approaches together, so the company commander immediately understood what needed to be done.

He instructed Sep. Ram Chander, 'Order Ram Kumar to engage the enemy. Hav. Jai Narain will coordinate the DF tasks with both Surja and Hari Ram for maximum damage. Platoon commanders are to engage the enemy with small arms only when the enemy is well within range. We should not waste any ammunition as our quantity is limited.'

Sep. Ram Chander replied, 'Roger, sir,' and conveyed the message on the radio.

The time now was 0455 hours. This was the moment Nk Ram Kumar had been waiting for. With Hav. Jai Narain on

the radio in communication with both the platoon commanders, Ram Kumar ordered his crew to fire both the 3-inch mortars as soon as the enemy was within range.

The damage on the Chinese assault was instant. The approaching enemy soldiers, who were now 300–400 yards from the platoons and closing in faster, froze in their tracks. Many died, but the survivors, still in their hundreds, charged at the platoon 7 and 8 positions from both sides.

Displaying extraordinary patience, the platoons lay in wait and when the Chinese were less than 100 yards away, the two platoon commanders ordered, 'Fire.'

All three sections of platoons 7 and 8 respectively, in addition to the platoon headquarters' posts and the 2-inch mortars, fired at the swarm of Chinese soldiers. They also threw grenades. From their new position, Nk Sahi Ram and his soldiers had joined too.

The night shook with the simultaneous firing of 400-odd weapons from the soldiers of both sides. While the Indian rifles could only be fired at a rate of 25–30 rounds per minute, as after each shot they had to be cocked, the LMG's rate of fire was more than 500 rounds per minute. The Chinese soldiers fired from their self-loading rifles as they attacked the platoon's section positions, but it was ineffective as the Indians were not only shielded well, but they had also sited their gun positions with overlapping firing arcs. The enemy's frontal assault was crushed. Most of them died and the survivors who ran back were chased by Indian fire until 100 yards when the section commanders ordered, 'Stop firing.'

The third wave of Chinese soldiers was defeated in just a matter of minutes.

The time now was 0515 hours. The platoons were jubilant because this was a big wave that had reached within a few yards

of their trenches. The Chinese soldiers had taken advantage of their overhead artillery fire that had pinned the Indians down in their trenches. Repulsing this wave meant two things for the Indians. One, the enemy would now suffer a psychological setback. And two, they would launch an even bigger attack.

Naib Subedar Surja Ram sounded like a winner when his voice floated through the radio set no. 88 of Sep. Ram Chander, 'Sir, we have repulsed the enemy successfully.'

Seconds later, the same radio crackled with the voice of Naib Subedar Hari Ram, 'Sir, the attack has been defeated. The enemy is either dead or they have run away.'

By now, Maj. Shaitan Singh was on the move. He had decided to reach platoon 8's headquarters which was around one kilometre from the company headquarters. As platoons 7 and 8 engaged the enemy's frontal assault, Maj. Shaitan Singh moved along with his radio operators, Sep. Ram Chander and Sep. Mohinder Singh and his LMG det, Sep. Nihal Singh.

They had barely crossed 250 yards from the company headquarters when the enemy's shelling recommenced. This time it lasted for ten minutes. Tragically, the lower part of Sep. Mohinder Singh's leg was blown off in this shelling.

As it was too risky to continue their move towards platoon 8 now, they decided to carry Sep. Mohinder Singh back to the company headquarters as he was bleeding heavily. There, they laid him down and did everything they could to stop the bleeding. Sep. Mohinder Singh was in a lot of pain but he kept his composure, giving them a fleeting feeling that they might be able to save his life. But he had lost a lot of blood in the meantime and died a few minutes later.

This time, over the sounds of shells that were landing around them, Maj. Shaitan Singh ordered Sep. Ram Chander,

'Try battalion headquarters again and if you get them, tell them we have defeated three attacks so far, but we need artillery support immediately.'

Sep. Ram Chander replied, 'Yes, sir.'

He tried to call but there was no response. Minutes later, at around 0525 hours, Maj. Shaitan Singh asked him to connect him to the three platoon commanders on the radio.

'Main tumhara commander hone ke nate yeh batana chahta hun ki tum bahut bahaduri se lad rahe ho. Mujhe tum sab pe garv hai. Indian Army ko tum pe garv hai aur poore desh ko tum pe garv hai. Maine artillery support manga hai aur jaldi hi hamein support milega. Reinforcements bhi try kar raha hun. Hum sab ko Bharat mata ke liye apne khoon ki akhri boond tak ladna hai. Jai Hind! (As your commander, I want to tell you that you are fighting very bravely. I'm proud of you. The Indian army and the whole nation is proud of you. I've asked for artillery support and we will soon get that. I'm also trying to get reinforcements. All of us will have to fight till the last drop of blood in our bodies to protect our Mother India. Jai Hind!)'

Fourth Wave of Chinese Attack, 6 a.m., 18 November 1962

For this attack, the Chinese had brought their RCL guns on wheelbarrows to the flanks of the Charlie Company. They were now attacking all positions incessantly with 75 mm and 57 mm bombs. Intermittently, they were using 132 mm rockets too.

In the forward platoons of 7 and 8, all sections knew that the Chinese soldiers would launch an attack as soon as the shelling stopped. Nk Gulab Singh, who was in section one, raised his head slightly as soon as the shelling stopped and observed that

a huge number of enemy soldiers were approaching from just two hundred yards away. He relayed their position to Naib Subedar Surja Ram and within seconds, the well-trained and practiced coordination was put to use once again. The charging enemy was greeted first by accurate 3-inch mortar fire by Nk Ram Kumar using both the guns as directed by Hav. Jai Narain in coordination with Naib Subedar Surja Ram and second, as soon as the still-charging enemy soldiers were within 50 yards, Nk Gulab Singh ordered, 'Fire.' Simultaneously, section two and three also started firing at them from the deep. This was the fourth enemy attack and it was successfully foiled once again within a few yards of the Indian positions. The few Chinese soldiers who survived retreated.

It was all quiet once again. Clearly, as before, the enemy was using the time to reorganize itself. Both Naib Subedar Surja Ram and Naib Subedar Hari Ram used this time to visit their sections and review the state of arms, ammunition and personnel. There were injuries to a few jawans, but surprisingly, there were no casualties. The only casualties the Charlie Company had suffered so far were the three jawans of the mortar section who had died in the initial shelling and that of the radio operator, Sep. Mohinder Singh.

To whichever section these two platoon commanders went, they were greeted with '*Bharat mata ki jai*' and '*Dada Kishan ki jai*'. The josh was palpable and it was the result of the leadership of these JCOs and their company commander, Maj. Shaitan Singh. The situation looked under control but both the experienced JCOs understood that this was the calm before the storm and therefore, they would have to plan ahead.

At 0610 hours, as dawn approached, the sky began to lighten. This was both good and bad. Good, because better visibility

meant better appreciation of the enemy's intentions, which
would in turn help in preparing a better counter-strategy, and
bad, because now the enemy would be able to see more clearly
and therefore target the Indian positions far more accurately. It
was the bad that outweighed the good for the Charlie Company
as so far, no artillery support from the brigade had been received.
But everyone was sure that the artillery would definitely come to
their rescue, because it was impossible to defend with weapons
that had less range than those the Chinese army was using. It
wasn't possible to defend anything as the Chinese could just
stay out of the range of the company's weapons and pound it to
smithereens.

During his rounds, Naib Subedar Surja Ram noticed that
two jawans in section one, being commanded by Nk Gulab
Singh, had been wounded by shrapnel. These jawans were
manning the LMG post and their injuries could compromise
the firing effectiveness of section one. He waved to Nk Singh
Ram who was manning the 2-inch mortar post and signalled
him to come over.

After Nk Singh Ram had arrived and saluted his platoon
commander, Naib Subedar Surja Ram said, 'Singh Ram, you
take over this LMG and go 40 yards ahead of the section and
take cover among the rocks. Go quickly before it is brighter and
hide yourself well there. When the enemy attacks, I want you to
take them in enfilade fire. Okay?'

Nk Singh Ram was a crack shot and he nodded with a faint
smile on his face.

'I want you to wait till the enemy is broadside to you. Only
then must you open fire. Clear?'

Nk Singh Ram looked at Nk Gulab Singh who was listening
and replied, 'Sir, don't worry, I will greet them well.'

With that, Naib Subedar Surja Ram sent the injured jawans to the rear at the platoon headquarters.

The total number of wounded at this time in platoon 7 were only three. After having toured all three sections, Naib Subedar Surja Ram returned to the platoon headquarters.

Meanwhile, at the company headquarters, a lot of things were going on in the mind of Maj. Shaitan Singh. The inability to communicate with the battalion headquarters was still understandable, given the distance of 9 miles, but what he was unable to understand was the lack of communication with Bravo and Delta Companies on Maggar Hill who couldn't have missed the sounds and lights of the shelling and the gunfire. Maggar Hill was only at a distance of 5 miles, well within the range of the company's radio set. He was also surprised by the lack of communication with 5 Jat, the nearest company of which was deployed at a distance of 5 miles on the Tsaka La road towards the south.

Maj. Shaitan Singh had only one option. He could send his radio operator physically to the battalion headquarters. But, he knew this wouldn't make a difference as the jawan would take at least four hours at the minimum to reach, even though it was all downhill from Rezang La. In addition, one of his radio operators was dead and the other was needed to communicate with the spread-out platoon locations. The vast area the company was tasked to defend, the lack of artillery support, the non-availability of MMGs, the unmined approach for the Chinese and less likelihood of reinforcement were hurting them badly. But even without these, the morale of the men Maj. Shaitan Singh was leading remained high. The jawans were brimming with confidence that they would be able to stop the Chinese and defend Bharat mata.

At this stage, all the courageous major could do was to be with his men and lead them towards their combined destiny. Because death was acceptable, but defeat was not.

As visibility started to get better, at around 0625 hours, the Chinese were seen bringing an MMG and positioning it atop a ridge 600 yards away. Even before the Indians could decide on a counter-strategy, the Chinese mortar and RCL bombs started to rain on all their locations.

It's a well-known fact that Prime Minister Jawaharlal Nehru abhorred violence. But the fact that he allowed his personal choice to eclipse the security needs of the nation by downsizing the army after 1947 was the real reason why India had to face humiliation at the hands of the Chinese in 1962. Nehru was indeed one of the finest global leaders of the time and the principal architect of the nation that Indians even today owe a lot to, but his complete dislike for the army can be deduced from this anecdote from the biography of Maj. Gen. A.A. Rudra written by Maj. Gen. D.K. Palit: 'Shortly after Independence, General (Robert) Lockhart as the army chief took a strategic plan to the prime minister, asking for a government directive on the defence policy. He came back to Jick's (Rudra's) office shell-shocked. When asked what happened, he replied, the PM took one look at my paper and blew his top. "Rubbish! Total rubbish!" he shouted. "We don't need a defence plan. Our policy is *ahimsa* (non-violence). We foresee no military threats. Scrap the army! The police are good enough to meet our security needs."'

10

18 November 1962, Brigade Headquarters, Chushul, 0630 hours

The Chinese attack was two-pronged as they had attacked the Indian positions at Gurung Hill and Rezang La simultaneously. As Brig. T.N. Raina oversees the Indian defence at Gurung Hill, which was the area expected to be attacked by the enemy and therefore well-fortified, he asks the CO, 13 Kumaon for the status of the Charlie Company. The CO orders Maj. Jatar to send a patrol from Maggar Hill to check as no one from 13 Kumaon is in communication with the Charlie Company. Meanwhile, the Chinese attacks on Rezang La continue unabated and the Indians succeed in defeating the fifth and the sixth enemy's waves. In a gallant attack, Nk Gulab Singh and L/Nk Singh Ram try to physically overpower the enemy's MMG.

Brig. T.N. Raina was in the operations room of 114 Brigade headquarters located in Chushul village near the airstrip when the first report of shelling on his brigade's defence positions reached him. He had received information moments ago that

the Chinese were pounding the 1/8 Gorkha Rifles posts on Gurung Hill.

Brig. T.N. Raina's defensive plan was complete and according to his orders, the tanks, the MMGs and the artillery guns had started to retaliate to the Chinese firing in equal measure.

At the moment, the brigadier, along with his operations team, was busy preparing contingencies in case the Chinese did succeed in penetrating the Indian defence. He was planning alternate positions to defend, in case retreats became necessary, so that Chushul airstrip could be saved.

Gurung Hill is a mountain situated in the range that is spread between the origin of the Chushul River near Tsaka La, and 30 miles north to it, where it drains into the Spanggur Lake. While China considers this range as a watershed and therefore, a 'traditional customary boundary', India claims its boundary 10 miles eastwards, where it cuts across the Spanggur Lake following a more prominent watershed.

Between Gurung Hill, which lies to the north, and Maggar Hill, which lies to the south, is the 1.5 mile-wide gap called the Spanggur Gap. On the east of this gap, is the Spanggur Lake and on the north-west is the village of Chushul.

Like a crown, the Gurung Hill supports a long ridge line. This ridge grows from the base of the Spanggur Gap at 14,000 feet and spreads northwards, soaring to a height of 17,800 feet. The ridge has a few flat sections towards its southern end and the Indian Army has given them interesting names like the Camel's Back, the Table Top and the Bump. Right in the middle of the ridge, towards the east, is a mountain called Black Top (18,640 ft). Black Top was under Chinese control in November 1962. Further on its north, Gurung Hill finally merges into another

hill feature called Thakung Heights, the extremity of which is washed by the Pangong Tso Lake.

Gurung Hill was being defended by two companies of 1/8 Gorkha Rifles, less a platoon. It had a section each of MMGs and 3-inch mortars and was also supported by two troops of AMX-13 tanks of 20 Lancers located in the Spanggur Gap. As explained earlier, 1/8 Gorkha Rifles had withdrawn from Srijap and Yula posts a month before. These companies were now being commanded by Capt. P.L. Kher. One of the disadvantages of Gurung Hill was that it was dominated by the much higher Black Top, under the enemy's control.

In addition, there was an artillery OP under the command of Second Lieutenant Shyamal Dev Goswamy. He had four trained jawans under him. This was the brigade's most-heavily protected frontier because allowing access to this meant Chushul was within easy reach of the enemy.

Taking cover of their shelling, when a company strength of enemy soldiers was observed to descend from Black Top to positions held by the Gorkhas on Gurung Hill, Capt. P.L. Kher led the Gorkhas well, but he was seriously injured in the process. In the meantime, Second Lieutenant S.D. Goswamy directed well-aimed artillery fire on the attacking Chinese. The young officer had ranged the enemy approaches well in advance and was ready for them. The firing stopped the Chinese soldiers in their tracks and as the Indian attack continued, they took shelter and returned to Black Top. The first wave had been defeated.

In the brigade's operations room, at around 0700 hours, Brig. T.N. Raina turned his attention towards the positions held by 13 Kumaon. To find out the latest situation there, he ordered his operator to connect him to Lt Col H.S. Dhingra, CO, 13 Kumaon.

Once the line was connected, he asked, 'Colonel, how are your companies doing?'

'Sir, all companies of 13 Kumaon are ready. So far, isolated bombs have fallen on Maggar Hill.'

'What about our post at Rezang La?'

'Even though there has been no communication since last night with the Charlie Company after the adjutant spoke to them, there have been no radio calls to report anything abnormal. The Chinese are busy on Gurung Hill, sir, as we can see.'

'I agree, but what if they have launched a two-pronged attack? We had initially appreciated that they might attempt to penetrate the pass to block the Chushul–Tsaka La road. Remember, colonel?'

The CO of 13 Kumaon agreed that they must check the status of the Charlie Company.

In the battalion headquarters of 13 Kumaon, Lt Col H.S. Dhingra placed the phone down and asked his operator to connect him with Maj. Jatar, the commander of Bravo and Delta Companies stationed atop Maggar Hill.

From the battalion headquarters, one could clearly see Maggar Hill, Spanggur Gap and the hills north of the gap like Gurung Hill, etc., but Rezang La, being on the south of the higher Maggar Hill, was not visible. Therefore, neither Lt Col H.S. Dhingra, nor any of the officers and JCOs of the battalion had a line of sight with Rezang La.

'Major Jatar, how are your companies doing?'

'Sir, we are safe. Just one injury so far to a cook. We have been shelled, but not heavily.'

'That's good, major.'

'We are ready to defend our positions, sir.'

'Great! What about Rezang La? We can't see their positions from here, but you can. Their communication line is down too. How are they doing?'

'Sir, like us they have been attacked too. We can hear sounds and see flashes. But I'm not sure of the exact situation on the ground.'

When the Chinese had attacked Rezang La, they had attacked Maggar Hill too. But unlike Rezang La, they had used only artillery on Maggar Hill, just enough bombs to pin them down in their trenches. There were no infantry attacks in the form of human waves on Maggar Hill. The only possible reason for this could have been that the Chinese wanted to keep the Indian soldiers stationed on Maggar Hill looking down while they carried out their business in Rezang La.

The CO continued, 'Try them on the radio and get back to me.'

'Roger, sir.'

Maj. Jatar was back in a few minutes, 'Sir, there is no reply.'

'Okay, send a patrol to Rezang La on foot and check.'

'Roger, sir.'

This was the only option available to the CO even though covering the distance on foot would take them a total of at least six hours since the distance was around 5 miles. But it was possible that they would be able to communicate with the Charlie Company over the radio after just one or two hours and obtain an 'all okay' report.

On Maj. Jatar's instructions, a patrol of four jawans was sent by the Delta Company to check the status of Rezang La and report as soon as possible. This patrol was led by Nk Roop Ram.

Let's get back to Gurung Hill now. At around 0730 hours, a second wave of a battalion strength of enemy soldiers started

to advance from Black Top. The Indians retaliated with intense artillery fire and tank ammunition, 3-inch mortars and MMGs. However, even this powerful firepower seemed underwhelming in the face of the sheer number of enemy soldiers.

Consequently, by 0930 hours, a portion of the Indian defences had been overrun. The Gorkha jawans fought valiantly and the Chinese suffered a large number of casualties, but the Chinese could not be stopped.

Even in the face of certain death, the artillery OP continued to engage the enemy with precision. At one stage, after Second Lieutenant Goswamy was wounded by shrapnel and lost consciousness, his second-in-command took over and continued firing the guns till the very end. Except for Goswamy, the entire observation party had been wiped out. The Chinese, after overrunning it, left Goswamy, thinking him dead. He would, however, be rescued the next day.

After the forward Indian positions on Gurung Hill had been run over, the enemy occupied the ridge and began to shell targets in the deep where the brigade headquarters lay.

The enemy kept on pushing ahead from the ridge, desperate and hungry, but the Indian firing from the tanks, led by Capt. A.K. Dewan, continued. Finally, after several hours of stalemate, the Indian tanks succeeded in puncturing the enemy's resolve and stopping their advance.

The Chinese did not cross the ridgeline on Gurung Hill for the rest of the day.

Rezang La, 0630 hours

Let's backtrack and get back to Rezang La where the Chinese attack was continuing relentlessly.

The positioning of the enemy's MMG was bad news for platoons 7 and 8, because it was out of range of all the weapons of the Charlie Company. The two 3-inch mortars were located a mile-plus in the deep behind both the platoons and its range of 1600 yards was insufficient, and the 2-inch mortars, which had a maximum range of 500 yards, were short too. This effectively meant that the Chinese could hurt the Indians with their MMG, but the Indians could do nothing to stop them.

Fifth Wave of Chinese Attack, 6.30 a.m., 18 November 1962

The next artillery attack came at 0630 hours. At that moment, Naib Subedar Surja Ram was in section two with Nk Ram Swaroop. He took cover in the trench and stayed there for the next ten minutes as the barrage lasted. When the artillery stopped, he realized that the attacking Chinese soldiers were only 40 yards away from their positions.

The defence had to open up quickly. But before they could react, within seconds of the artillery stopping, the Chinese MMG opened up to give covering fire to their infantry attackers. This was the fifth wave of Chinese soldiers.

But the enemy had underestimated the Indians. The attacking Chinese soldiers were fired on simultaneously from three directions: Ram Swaroop's section from the front, Gulab Singh's section from their left and Singh Ram from their right.

Singh Ram's enfilade engagement shocked them. But the enemy soldiers didn't stop coming. As the ones in front died due to the Indian firing, the ones behind them picked up the dead soldiers' weapons and this cycle continued for a long time.

Tragically, Nk Singh Ram's gun fell silent as it ran out of rounds. Realizing this, the last of the few Chinese soldiers slowly began approaching his hidden position. As soon as they were a few feet from Singh Ram, he leapt out and started to fight with them in hand-to-hand combat.

It was a sight to watch as the six-feet-two-inches tall Indian jawan lifted the handful of Chinese soldiers and fought with them in the rocky terrain, visible at one moment and invisible at the next. Ram Swaroop and Gulab Singh's section gave him cover and brought down the enemies who were trying to fire at him keeping out of his reach. Within minutes, it was all quiet.

The enemy's attack had been beaten and the Indians had saved themselves by the skin of their teeth.

But tragically, the MMG had done its damage. Two soldiers from platoon 7 had lost their lives and three more were seriously injured. The number of available soldiers with platoon 7 had dwindled now and defending their spread-out positions with reduced manpower in the face of the Chinese army, superior in both numbers and firepower, was impossible for any army of the world, however well-trained and motivated they may be.

Naib Subedar Surja Ram, therefore, decided to concentrate all his soldiers and weapons at one location, so as to defend the platoon's area of responsibility better. In the circumstances, it made perfect sense.

The platoon commander got into action immediately and within minutes, he was successful in moving everyone to section one, except for Nk Sahi Ram, with whom he had lost communication.

Once everyone had settled down, he turned towards Nk Gulab Singh and said, 'Gulab, if we don't do something about that MMG, we will lose this position.'

Nk Gulab Singh firmly looked into his eyes and said, 'Yes, sir.'

'But the question is, what should we do? The MMG is out of the range of our weapons.'

Gulab Singh paused for a few seconds before answering, 'Sir, Singh Ram and I can reach there and overpower the MMG post.'

'Are you out of your mind? No way! You can't just go there unseen, kill everyone and take over their weapon.'

But Nk Gulab Singh was firm, 'Sir, please give us a chance.'

'Gulab, this is not possible. The chances of success are almost zero.'

'That's right, sir. Almost zero, but not *zero*. We will bring the gun crew down and take it over.'

'No, that is a suicidal mission. And I can't approve a mission like that.'

'So, you tell me, sir. Do you have any other option?'

Naib Subedar Surja Ram looked at Nk Gulab Singh's face. It was taut, his lips a thin line and his eyes sparkling. Gulab Singh and Singh Ram were his best soldiers. But, in his heart of hearts, Surja knew that, under the circumstances, they had no other option. Finally, he approved it.

'Okay, go ahead, Gulab. Fight well.'

Nk Gulab Singh turned and drew Singh Ram's attention by raising his voice, since Singh Ram was around 40 feet away hiding among the boulders, 'Singh Ram, let's go and capture that MMG.'

'Yes, sir.' Singh Ram's voice resonated the same confidence. There was no delay in responding. It was as if he was thinking along the same lines too.

Crawling over the dead Chinese soldiers' bodies, Nk Gulab Singh started to move towards the MMG position. After 40 yards, L/Nk Singh Ram joined him and the two continued stealthily for the next 500 yards.

When they reached the rock they had identified as their final protection, both knew that now their target was only 70 yards away. They lifted their heads above the edge and saw the three Chinese soldiers manning the MMG. Crouching in a depression in a rock next to them was another Chinese platoon in waiting for the next wave of attack.

Meanwhile, Naib Subedar Surja Ram was wondering what was happening. It had been quiet for the last fifteen minutes. Surprisingly, there was no artillery or MMG fire from the Chinese. They must have been busy reorganizing themselves and therefore, this indeed was their best window of opportunity.

Both Nk Gulab Singh and Nk Singh Ram had LMGs with them. If their attempt failed, not only would the Charlie Company lose two experienced soldiers, they would be minus two LMGs too, leaving them with only seven.

But on that morning in Rezang La, with their hearts beating wildly for the love of their nation, and their top fitness and mental alertness keeping the hope of capturing the enemy weapon a certain possibility, the two soldiers looked at each other and nodded. It was time.

At 0645 hours, Naib Subedar Surja Ram and all the others from platoon 7 who had taken positions in section one heard the battle cry, '*Dada Kishan ki jai.*'

Though Nk Gulab Singh and L/Nk Singh Ram were not visible to the Indians before this, once they emerged out of hiding and attacked the enemy, they could be seen. Sunrise was just ten minutes away and visibility was nearly one mile.

The Indian soldiers' attack was a brave and a desperate one. At first, as soon as the enemy soldiers spotted the Indians attacking them, they were shocked.

As the Chinese gun crew began to move into positions to fire, the gap between the Indian attackers and the MMG started to reduce. But all they took were a few seconds and the weapon was spewing fire in the direction of Nk Gulab Singh and L/Nk Singh Ram.

This was the time the availability of Indian artillery would have increased the chances of success of their mission manifold. But all the Indians could do was watch.

Nk Gulab Singh was a few feet ahead and he was the first to fall. But L/Nk Singh Ram continued to narrow the gap, firing his LMG as he went along and finally jumping into the air and falling on top of the MMG.

For a few seconds, Naib Subedar Surja Ram and the others were sure he would succeed in capturing the gun all by himself. But he remained there, unmoving. When they saw the Chinese soldiers rejoicing a few seconds later, platoon 7 realized that their gallant attempt had failed. It would be three months later that the Indian Army would realize that L/Nk Singh Ram had fallen five feet short, but for Surja and the others, who were watching him from behind, it must have given them the impression that he had fallen on top of the gun.

Moments later, Naib Subedar Surja Ram called Maj. Shaitan Singh on the radio and reported, 'Sir, we have lost a few jawans, but we are holding our position here.'

'Very good, Surja sahab. *Humko peechhe nahi hatna hai* (We should not step back).'

'Sir, *main aapko vachan deta hun, platoon 7 ka ek bhi aadmi, ek kadam bhi peechhe nahi rakhega. Hamare pass ammunition*

*kam hai, lekin uske khatam hone ke baad bhi hum bayonet ki
ladai ladenge, par peechhe nahi hatenge* (Sir, I promise you, no
soldier from platoon 7 will take even one step back. We have
less ammunition left, and after it gets over, we will fight with
bayonets, but we will not step back).'

Naib Subedar Surja Ram's voice was calm and controlled as
he went on to describe the gallant attack of Nk Gulab Singh and
L/Nk Singh Ram on the enemy's MMG.

By now, platoon 8 had defeated the attack on them too.
The pattern employed by the Chinese was similar: fifteen
minutes of mortar fire, followed by their infantry's assault in
greater numbers. But unlike platoon 9, since platoon 8 was
right in the middle of the pass with very little natural cover,
the casualties here were more. Sep. Dharampal Dahiya, the
company's lone medical assistant, did the best he could,
running from section to section and providing medical aid. To
the ones injured gravely and in terrible pain, he administered
morphine shots too.

The artillery attack of 0630 hours had created havoc on
the 3-inch mortar section too, besides platoons 7 and 8. In the
mortar section, the second mortar had been damaged this time
and both the jawans manning it were killed. In addition, a bullet
had passed through the lower back of Nk Ram Kumar, entering
from one side and coming out of the other, miraculously missing
his spine.

As soon as the bombs stopped, Nk Ram Kumar started to
reorganize the mortar section. He ordered L/Nk Siri Ram to take
over the number one mortar with L/Nk Roshan Singh assisting
him. After that, he himself took over the number 2 mortar and
ordered Nk Surat Singh, a Pioneer NCO who had arrived a
day earlier to help with some digging work, to be his assistant.

Both the mortars were now without sights and except for Nk Ram Kumar, the more experienced mortar crew was dead.

As we have seen, the fifth wave of the enemy was double-pronged and therefore, when platoon 7 was attacked, the Chinese had attacked platoon 8 too. So far, no damage had been done to platoon 9 and the company headquarters. Maj. Shaitan Singh knew that the first targets of the Chinese were platoon 7, platoon 8 and the 3-inch mortar section. Once that was done, they could easily isolate the company headquarters and platoon 9 positions.

As the enemy's artillery paused, Naib Subedar Hari Ram, who was looking out from his position, was surprised to see the Chinese bring in dozens of yaks. On the backs of these sturdy animals, LMGs and MMGs had been mounted.

The line of yaks standing atop the ridge and looking down on the platoon 8 positions was at a distance of approximately 1000 yards. Naib Subedar Hari Ram saw the Chinese soldiers dismount one of the MMGs from a yak and rig it on the ridge. The situation called for immediate action.

Naib Subedar Hari Ram got in touch with Nk Ram Kumar and gave him the exact position. Within seconds, both the 3-inch mortars started to fire. The result was instant and the animals turned wild and ran away. The relief for the Indians, however, was only temporary.

The Chinese responded with mortar and RCL fire. They also used the MMG that they had already dismounted. The Chinese were using better firepower and soon one of the Indian 2-inch mortar guns was completely destroyed. To make matters worse, another MMG that wasn't visible to platoon 8 and was farther off opened fire. Not having an MMG with the company continued to hurt them gravely.

By the time the Chinese bombs stopped, considerable damage had been done to platoon 8. Most of the jawans had either died or had been seriously injured. One MMG bullet had grazed Naib Subedar Hari Ram's head too. To stop the bleeding, Sep. Dharampal Dahiya had bandaged him.

The sun finally rose at 0655 hours. There was eerie silence now. The visibility improved to a few thousand yards soon and up to the distance they could see, there was the debris of bombs. In the nullahs, the bodies of Chinese soldiers were still lying, though most had been taken away under the cover of darkness. It had stopped snowing.

Platoons 7 and 8 had considerably thinned down and now all they could do was wait. The Indians had very limited ammunition left and it was not possible to waste this on any kind of daredevilry. Maj. Shaitan Singh's orders were clear: they were to defend the Indian territory till the last man and last bullet.

Every single Indian jawan was prepared to fight it out. But right now, as the white desert around them woke up, the beauty of nature was in sharp contrast to the humans fighting a bloody battle over it.

This brief respite ended at 0710 hours when, for the next twenty minutes, the Chinese began bombing platoons 7 and 8 again, the heaviest so far. They used every arsenal they had and that too at their top firing rate. The idea, clearly, was to decimate the stubborn Indian forward positions irrespective of the cost.

But the Chinese had no idea what was in store for them.

As soon as the bombing stopped at around 0730 hours, as expected, the attacking Chinese infantry soldiers were just 40 yards from section three being commanded by Nk Chandgi Ram.

Nk Hukum Chand had anticipated this, because section three was bang in their way to the platoon 8 headquarters. He knew, therefore, that from the Chinese side, annihilating section three would be the first focus of their overall strategy. Also appreciating the fact that section three would not be able to survive the focused attack by the Chinese on its own, Nk Hukum Chand had already brought an additional LMG from section two to engage the enemy. In this way, two back-to-back smaller waves of enemy attacks were beaten back.

The Chinese regrouped and attacked again. But this time, the Indians were more than ready and the daylight was helping them. As soon as the Chinese soldiers made the charge on foot, they were pounded by 3-inch mortars and as soon as some of them came in the range of the small arms of the Indians, they were engaged by all three sections using LMGs and rifles. The Indians jawans threw grenades too. In this manner, two smaller waves were defeated.

Sixth Wave of Chinese Attack, 7.40 a.m., 18 November 1962

The Chinese recommenced their mortar shelling and both their MMGs started to engage from two fronts in their sixth major attack. By this point, the Indian soldiers of platoon 8 were out of ammunition. There can be nothing more tragic when a soldier wants to fight but his ammunition runs out.

Realizing that this was the end, Nk Chandgi Ram shouted, '*Dada Kishan ki jai*' and led section three on a bayonet strike. The jawans jumped out of their trenches and holding their rifles with attached bayonets on them, charged at the approaching enemy. The surroundings echoed the brave Ahir soldiers' battle cry.

Right after Nk Chandgi Ram's section three, Hav. Rama Nand, Sep. Khoob Ram and other jawans from section two and the 2-inch mortar section charged the approaching Chinese with bayonets. The counter-attack by the Indians was so fierce that the Chinese stopped firing temporarily.

By now, Nk Hukum Chand, the section commander of section one, had perished and the section was being commanded by L/Nk Raghu Nath. He defeated the Chinese attack on his section but the Chinese were now far too many to stop and the section fell fighting. In the next few minutes, platoon 8 ceased to exist. Every soldier had fired the last round and no one from the platoon had survived.

Until his last breath, Naib Subedar Hari Ram was reporting the position on the ground to company commander Maj. Shaitan Singh.

Platoon 7 was attacked in a similar manner and they could defeat several smaller waves, but finally, when their ammunition was exhausted, Naib Subedar Surja Ram called Maj. Shaitan Singh and said, 'Sir, our ammunition is over. We are now preparing to leave our positions for a hand-to-hand battle.'

Maj. Shaitan Singh knew what this meant and he said, 'Approved, Surja sahab,' and then, with steel in his voice, the company commander roared, 'Dada Kishan ki jai.'

'Dada Kishan ki jai,' came the reply.

This was the last the Charlie Company would hear from Naib Subedar Surja Ram or any of the jawans from platoon 7, ever. Even in their deaths, the soldiers of the Charlie Company would hold their positions and make their platoon commander, their company commander, and the entire Indian Army and the whole nation proud.

Three months after the war, when the bodies of Naib Subedar Surja Ram and five other soldiers of platoon 7 were recovered, they were found 10 metres ahead of their trenches with multiple bullet and bayonet wounds. The jawans and their JCO of the Charlie Company would die fighting like heroes, like true sons of India.

At that moment in the company headquarters though, the company commander was proud of the way platoons 7 and 8 had defended the Indian border. As their leader, he was directly responsible for not just training them, but also motivating them. He knew each of them well: where they were from, the names of their wives, the names of their children, their small joys and their occasional worries. For him, their death meant the death of his own family members. Although he was incredibly proud, Maj. Shaitan Singh also felt sad.

But he was no ordinary officer. A quiet but professional soldier, the major quickly controlled his emotions and decided to continue fighting. The Charlie Company would die, rather than turn its back now. Whether help from the rear was received in time or not, they would fight till the finish.

At around 0800 hours, the Chinese fired a green Very signal announcing their win over platoons 7 and 8. Maj. Shaitan Singh knew that the only way to blunt the enemy's further plans was to act early.

He moved out of the company headquarters with his radio operator and started to watch the build-up through his binoculars. He could see that the Chinese were reorganizing themselves at both ends of the ridge.

Maj. Shaitan Singh called Nk Ram Kumar who was at the mortar post, 'Ram Kumar, how many bombs are left with us?'

'Sir, around 400 are left. We have used up 600 bombs.'

The situation in the mortar section was grim. The Chinese army had been targeting it right from the start. In three hours and five minutes, the mortar section had fired at a speed of 300 rounds per mortar. This amounted to 100 rounds per mortar gun per hour. Considering the fact that seven out of ten soldiers manning the mortar guns had been martyred during this period and the guns had been hit by bombs on three occasions, this was an incredible firing rate by any account.

Nk Ram Kumar would later recall that the minus 24-degrees temperature had helped to keep the barrel working despite firing at such a rate. Even with the sights of both the guns damaged, the mortars continued to wreak havoc on the enemy.

Right now, their worry was, just like the ammunition of LMGs and rifles, the bombs would get over soon too.

'Ram Kumar, we have to be very careful with our bombs,' the major cautioned.

'Yes, sir.'

Yaks are domesticated cattle that have long hair and are found in the Himalayan region and higher altitudes of other parts of Asia. It is not clear when yaks were domesticated, but studies suggest that they were first bred as beasts of burden for the caravans of the Himalayan trade routes. Yaks have short legs, small ears, a wide forehead and a bulky frame. In the wild, yaks can weigh as much as 1000 kg, though domestic yaks don't usually weigh more than 600 kg. Yaks' lung capacity is about three times that of the cattle found at lower altitudes, and their ability to transport oxygen through their blood is better as they have more and smaller red blood cells. It is due to these natural adaptations

and the fact that yaks have long hair and thick skin that is devoid of sweat glands that these animals can survive in temperatures of up to minus 40 degrees Celsius in very high altitudes. Today, domesticated yaks number at least 12 million in the world and have been bred over time with cattle for obedience and a higher milk yield. Yaks are also used for ploughing and threshing of crops, as well as for meat, hides and fibre. The dried dung of the yak is the only available fuel on the Tibetan plateau that is devoid of trees.

11

18 November 1962, Rezang La, 0810 hours

By now, the Indians have lost platoons 7 and 8. From the company headquarters, Maj. Shaitan Singh can see the Chinese atop the overrun Indian positions. But he still has platoon 9 and the 3-inch mortar section intact, though the two mortar guns are now without their sights and seven crew out of ten have been martyred due to direct hits. The Chinese meanwhile launch their seventh wave as the company commander decides to retake platoon 7's position where the last surviving jawans under Nk Sahi Ram engage the enemy and inflict large casualties before they are overpowered and martyred. Maj. Shaitan Singh is fatally wounded in the process and Nk Ram Kumar inflicts damage till the last minute of the Indian resistance.

The Chinese soldiers had by now reached the platoon 7 and 8 positions. Maj. Shaitan Singh could see them through his binoculars as they went about organizing themselves to launch the next phase of attack on platoon 9, company headquarters and the 3-inch mortar section.

Maj. Shaitan Singh reached out to Naib Subedar Ram Chander on the radio, 'Ram Chander sahab, the attack can come at any second. Is the platoon ready?'

Naib Subedar Ram Chander was as confident as ever, 'Sir, we are ready. All the soldiers are at their posts.'

'Any injuries so far?'

'Only minor injuries, sir, but no casualties.'

The Chinese artillery attack had so far left platoon 9 to itself. Since company headquarters was located close to platoon 9, Maj. Shaitan Singh knew he would soon have to pool all the weapons and remaining manpower at one location.

The entire focus of the Chinese troops who had gathered in whatever remained of platoon 7 was towards the westerly direction.

The battle was in a state of an uneasy silence as the two sides eyeballed each other. Maj. Shaitan Singh knew that while he had less than fifty soldiers with him now and very limited ammunition and bombs, the Chinese had thousands of soldiers to attack the Indian positions in human waves after waves and, practically, limitless arms and ammunition. While the Chinese seemed to have an unlimited supply of arms, ammunition and soldiers, all the Charlie Company had was raw courage and an indomitable spirit.

The time now was 0830 hours and something miraculous was about to unfold.

As the attention of the gathered Chinese soldiers was towards the west, a volley of LMG and rifle fire hit them from the north. This totally unexpected fire from just a few hundred yards and from a totally unexpected direction filled the Chinese troops with panic and they jumped for cover. This firing brought numerous Chinese soldiers down.

It took Maj. Shaitan Singh only a fraction of second to realize whose guns had brought so many Chinese down. It had to be Naib Subedar Surja Ram's section three that was deployed at an alternate location by the platoon commander right at the beginning.

It was clear that Nk Sahi Ram and his section had not withdrawn after the attack. Instead, they had decided to follow the last orders of Naib Subedar Surja Ram, their platoon commander, who was no longer alive.

Nk Sahi Ram and the jawans of his section must have been aware of what would happen next. They were in a totally isolated position and within minutes, they were surrounded by the Chinese from all sides. But the brave jawans went down fighting, probably in loyalty for their platoon as they realized that everyone from their platoon, including their commander, had died defending the platoon's position.

Maj. Shaitan Singh and all the others watched the last stand of Nk Sahi Ram and his jawans through binoculars with pride.

Now, for the first time, the Chinese brought in a 57 mm RCL to a visible distance in the battlefield and positioned it on top of the ridge at 0840 hours.

Maj. Shaitan Singh reviewed the situation. The area north of the pass was clear of Chinese due to Nk Sahi Ram and his section's last stand. East was all clear with no Chinese to assault them from the front. At the rear location of the company, i.e., to the west of the company headquarters too, there were no Chinese. This meant that the Chinese were only present in the south.

The Chinese, who were now concentrated in the location where platoon 8 was, started firing at platoon 9, company headquarters and the mortar section with two MMGs. They

were firing at the Indians from a distance of around 1000 yards and the only weapon the Indians could use to retaliate was the 3-inch mortar. But the problem was that the Charlie Company had limited bombs remaining. It was now, therefore, time to take a major decision.

After a lot of thought, Maj. Shaitan Singh decided to retake platoon 7's position. He radioed Naib Subedar Ram Chander, the platoon commander of platoon 9, who was present in section three at the time.

Over the fire of the enemy, Maj. Shaitan Singh shouted into the mouthpiece of the radio set, 'Ram Chander, we will retake platoon 7's position. Listen carefully, with me your section one and two will also move.'

'Roger, sir.'

After this, Maj. Shaitan Singh turned towards Sep. Ram Chander and said, 'Go and get Havildar Phul Singh.'

While Maj. Shaitan Singh was waiting, he went out briefly to relook at the situation when he was hit by bullets in his hand and on his shoulder. He immediately got back into the company headquarters. A sepoy who was present there pulled out a first aid kit and bandaged him.

Hav. Phul Singh was the section commander of the 2-inch mortar post of platoon 9. When he arrived, Maj. Shaitan Singh said, 'Phul Singh, we are retaking platoon 7's position.'

'Roger, sir.'

Then he looked at CHM Harphul Singh and said, 'Harphul, I want you to take section one and section two of platoon 9 with you and move to the northernmost edge of the company headquarters. We will give you covering LMG fire. Once you reach there, wait for me to join you. Okay?'

'Yes, sir.'

CHM Harphul Singh left immediately.

Maj. Shaitan Singh wanted to leave two LMGs before he went. One was already with Sep. Nihal Singh.

He asked those who were present, 'I want a volunteer for the second LMG.'

Before the others present could say anything, Hav. Phul Singh, who was still at the company headquarters, said, 'Sir, I volunteer.'

'Excellent.'

Then the major turned and sited both the LMGs facing south, in a position that was in-between the 3-inch mortar section and the company headquarters.

Satisfied, he looked at Hav. Phul Singh and Sep. Nihal Singh and said, 'Your orders are to engage the MMGs. Stop the enemy for as long as you can.'

Both replied, 'Roger, sir.'

Maj. Shaitan Singh's plan after reaching the place where CHM Harphul was waiting was simple. First, he, along with sections one and two, under covering fire, would make a rush northward. Then, section three with Naib Subedar Ram Chander would follow. Once all of them were safe, both LMG handlers were to take cover of the mortar fire and leave for the same location. And finally, the mortar section would do the same action after dismantling the mortars. It was a phased operation of shifting position under covering fire.

The plan seemed to work for a while, but when Maj. Shaitan Singh and the soldiers accompanying him were 400 yards from the company headquarters, an unseen MMG cut through their column. Maj. Shaitan Singh got hit by a burst of MMG fire in his abdomen. Others fell down too. CHM Harphul Singh shouted for everyone to turn left and he hooked

the major's left arm and helped him move for 200 yards till they were safe.

Out of the twenty men from the platoon and eight from the company headquarters, only five survived the targeted attack of the enemy's MMG.

Simultaneously, section three of platoon 9 also came under heavy fire. By now, jawans of section three had exhausted their LMG and rifle ammunition.

As CHM Harphul Singh turned, he got a final glimpse of Lance Hav. Balbir Singh, the section commander, leading his three men in a bayonet charge into a mass of grey uniforms of Chinese soldiers. Section three, which was located 400 yards ahead of platoon 9 near the knoll, ceased to exist in a few minutes.

The Chinese soldiers now started edging towards the company headquarters and the 3-inch mortar section. When they were just 150 yards away, the 3-inch mortar had to be fired at an elevation of almost 80 degrees. Soon, the mortar's usability had run out as the Chinese had reached closer than the weapon's minimum range of 125 yards.

At that moment, the situation at the mortar section was about to turn for the worse. Nk Surat Singh was hit by a splinter charge and he died.

Over the ear-splitting sound of enemy fire, Nk Ram Kumar ordered L/Nk Siri Ram and L/Nk Roshan Singh, 'Both of you disable your mortar and leave. Now!'

But the courageous soldiers replied, 'No, sir.'

Nk Ram Kumar persisted, 'There are just a few bombs remaining now. It would be of no purpose to stay any longer.'

'Sir, we will not leave you alone here.' The loyal soldiers refused to leave without Nk Ram Kumar.

By now, Nk Ram Kumar had been riddled with many bullets and his nose had been blasted away by shrapnel.

Tragically, as the two soldiers were loading a new round, a burst of MMG fire stopped them midway and both died. Now, out of ten soldiers who were present in the mortar section at the beginning, only one was alive—Nk Ram Kumar.

The time was 0900 hours.

Seventh Wave of Chinese Attack, 9 a.m., 18 November 1962

By any standard, it was an unequal fight, but Hav. Phul Singh and Sep. Nihal Singh, LMG gunners of the Charlie Company located east of the mortar position, were continuously firing at the flaming MMGs of the Chinese and the enemy soldiers who were edging closer with every passing second.

Hav. Phul Singh managed to neutralize one of the guns briefly, but their location was hit by a 75 mm anti-tank rocket soon after. After this, Hav. Phul Singh stopped firing as he was fatally wounded by shrapnel.

Even as Hav. Phul Singh, one of the most respected NCOs of the unit, lay next to him without breathing, Sep. Nihal Singh kept on firing. Within a few minutes, both his hands were shot through by an MMG bullet and the LMG fell out of his hands. Sep. Nihal Singh lay down and tried to dismantle his LMG, as ordered by the company commander, but his hands were bleeding heavily and refused to obey the commands of his brain. He was helpless, lying there among the martyred soldiers of his company.

When there was no fire from the Indian side for a few minutes, a large number of Chinese soldiers descended on the LMG's position. This was their seventh major wave.

The Chinese had simultaneously bombed platoon 9 too. Soon, there was no resistance coming from this platoon's positions and it was an indication for them that the Indian resistance was over.

Sep. Nihal Singh was finally taken prisoner.

The Chinese soldier kicked the LMG out of Nihal Singh's reach and asked him in Hindi, '*Tumhara naam kya hai*? (What is your name?)'

Nihal Singh, who was in a lot of pain as he was bleeding from both his arms, replied, 'Nihal Singh.'

The Chinese asked his next question, '*Tumhare CO ka kya naam hai*? (What is your CO's name?)'

'No,' shouted Sep. Nihal Singh.

The Chinese took him away, but the courageous sepoy would escape from Chinese custody a day later.

Naib Subedar Ram Chander, the platoon commander of platoon 9, who was seriously wounded, was taken prisoner too. But he was in an unconscious state at the time. A few hours later, lying in the open, he would see a line of trucks filled with the bodies of Chinese soldiers. He would be released six months after the war and share details about the battle.

But the Chinese had no idea that the Charlie Company had not given up yet. There was one man still standing.

The time was 0915 hours and Nk Ram Kumar had by now disabled his mortar. He was contemplating his next course of action when he saw the Chinese soldiers less than 20 yards away. Right behind him was the reverse slope and to escape, all he had to do was roll down. He had done his job well. Only seven bombs out of the 1000 that his section had prepared were remaining.

His entire section had been martyred. One thing he would certainly not do was to even think about returning back to the

battalion. This was where his buddies had laid down their lives and this was where he would lay down his. But not before he could inflict further damage upon the Chinese.

Nk Ram Kumar had no personal weapon with him and therefore, he moved towards his left unseen and got inside the damaged company headquarters. Inside, he found a rifle. He cocked it and sat down waiting, staring at the entrance. Nk Ram Kumar was badly wounded with as many as nine bullet marks on him by now and his nose had been blasted away. In the middle of his face all that remained were two bloodied holes. His clothes were soaked in blood. As he waited, looking at the entrance through the rifle's sight, his eyes were heavy and he was barely breathing.

He killed the first enemy soldier who popped his head inside with a single shot. That's when grenades were thrown inside the company headquarters through every hole. Nk Ram Kumar set his rifle aside and lay down in a foetal position. That's when he lost consciousness. The Chinese were, however, still scared and, seconds later, they set the company headquarters on fire.

Due to the intense heat, Nk Ram Kumar woke up with a start. He must have been knocked out for just a few minutes. Dazed, he looked around and realized that his clothes were on fire and the company headquarters was full of smoke. He was unable to breathe. He found an opening and with his breathing laboured due to exhaustion and lack of oxygen, he escaped through it.

Outside, the entire place seemed to be on fire. Smoke was coming from every direction. There was no sign of the Chinese now.

Nk Ram Kumar crawled for some distance before rolling down the hill. On the way, he lost consciousness again.

Finally, the next day, he limped and somehow made it to the battalion headquarters.

By now, Maj. Shaitan Singh had been carried to a lower location through a gully with the support of CHM Harphul Singh and four others including Sep. Ram Chander. The company commander was in a lot of pain and he said he wanted to sit down.

Then he said, 'Please open my belt. I'm in a lot of pain.'

The batman bent forward and when he put his hand inside, he realized that the burst of bullets had done a lot of damage. If he removed the belt, the internal bleeding would increase and the intestines would come out. He looked at the CHM.

CHM Harphul Singh said, 'Sir, just some more distance. We need to take you to a hospital.'

By this time, the gallant company commander had realized that he would not survive. He said, 'I want you to leave me here and go to the battalion headquarters. Report to the CO how bravely our company fought.'

The jawans persisted but the major urged them, 'Go fast, save yourselves. The enemy can come here any time.'

The jawans had tears in their eyes. Finally, after helping their company commander to rest against a boulder, the jawans reluctantly left. By now, Maj. Shaitan Singh had given his personal pistol to Sep. Mamchand of platoon 9 who was with them, to deposit it with the battalion quartermaster so that it would not fall into the enemy's hands.

Maj. Shaitan Singh was hardly breathing when the jawans left him to follow his last order—to save their lives and to report to the CO how the Charlie Company fought the battle. The Indian Army would find him at the same spot three months later, his whole body covered in snow, except his face.

When this handful of jawans reached the administrative base of the Charlie Company, they found it to be on fire and no staff was present there. Soon, they saw a vehicle approach them and as they were identified, they were taken to the battalion headquarters.

On arrival, the first thing Sep. Mamchand did was to safely deposit the company commander's pistol to the Battalion Quarter Master Havildar (BQMH) Nand Kishore.

First Lt Col H.S. Dhingra and then Brig. T.N. Raina gave the survivors a patient hearing on the night of 18 November 1962.

The Central Intelligence Agency (CIA) started to actively support and train the Tibetan guerrillas against the Chinese occupation of Tibet from the early 1950s. This involved rigorous training of the fighters in a secret facility called Camp Hale in Colorado, USA, and dropping of arms in areas of Tibet held by the guerrillas. But the US's strategy had a fatal flaw. They decided not to drop radio sets as they were wary that the Tibetans would not follow the secrecy protocol during communications. Another reason was the fact that the radios would require a lot of batteries and due to the aircraft's weight restrictions, they chose arms over radios and batteries. Lack of internal communication forced the Tibetans to concentrate in one location, making them an easy target for the Chinese air attacks. Although the CIA's support failed and the 'CIA Tibetan programme' was shut down in 1974, one of the bright spots was the fact that the escape of the Dalai Lama was led by CIA's trained fighters who escorted the spiritual leader, his family and his staff through guerrilla-held territories, making it one of the greatest escape mysteries of the previous century.

12

18 November 1962, 1600 hours, Chinese Side of
the Border

*The unconscious jawans from platoon 9 and company headquarters
are taken as POWs (prisoners of war) by China. Naib Subedar
Ram Chander remembers gaining consciousness after some time and
witnessing heaps of bodies of Chinese soldiers being taken away from
the battlefield. When Sep. Nihal Singh wakes up in Chinese custody,
he spots an opportunity and successfully escapes. Finally, in the first
week of February 1963, a Ladakhi shepherd discovers the frozen
bodies of Indian soldiers and informs the army. The search party,
led by the brigade commander, Brig. T.N. Raina arrives in Rezang
La on 10 February 1963 and are moved by the last man, last bullet
stand of the Indian soldiers as they witness them frozen in their battle
positions. The bodies of these bravehearts are then consigned to flames
amid the chanting of Vedic mantras by the brigade commander
himself. Maj. Shaitan Singh's body is discovered at the same spot
from where he had given his last order. The company commander's
body is flown to Jodhpur where he is cremated with full state honours.*

Naib Subedar Ram Chander woke up with a start. He had no idea how many hours he had been unconscious. He found himself on a moving vehicle, which had stopped at that instant, waking him up. Something was not right. The JCO closed his eyes seconds before he felt hands grab him and transfer him to a larger vehicle. As he was being carried by two Chinese soldiers on a stretcher, he opened his eyes slightly and saw a column of trucks with bodies of Chinese soldiers heaped on them. He closed his eyes again.

Sep. Nihal Singh was in Chinese custody too. The Chinese had offered him a biscuit and he had taken a bite. But within seconds, he realized that he was accepting food given by the enemy and spat the biscuit out.

At some point, late in the night, Sep. Nihal Singh noticed that the two men who were guarding him had walked a little distance away from where he was, to smoke and chat. The jawan, who was only twenty-one years old at the time, took an instant decision and quietly slipped out. He had no idea how far he was from the Indian border.

After a few hundred yards, he ducked behind a boulder when a flare was fired by the Chinese and the entire surroundings lit up. The enemy must have searched for movements but he remained still among the rocks. After a few moments, he got up and started to walk again.

He was wounded, he was tired, and he was thirsty. After a few hundred yards, he came across a dog. In October, when the Charlie Company had arrived, they had fed this dog on a few occasions. The dog looked at him and started to walk in a particular direction.

Sep. Nihal Singh followed the dog and after a few hours, he reached the battalion headquarters. Although Sep. Nihal Singh

has consistently said that a dog had helped him find the border, some believe he must have been hallucinating. In any case, considering the fact that he escaped and survived the mind-numbing walk through a frigid country after a war, in which almost all the soldiers of the company he considered as his family were dead, and he was bleeding from both his hands due to bullet injuries, the account given by the brave soldier seems plausible.

A war is the ultimate challenge that tests the human's nerves. Men perceived as bold sometimes simply turn their tails inwards and retreat, whereas unassuming and simple men might show their true mettle in the face of the enemy fire.

When a soldier is standing in a trench, aiming his weapon and firing at the enemy in the face of incoming fire, he is actually putting into action all that he had learned. But, when an enemy's bullet passes through the head of the soldier standing next to him, whom he had probably shared a cup of tea with a few moments before, the effect of training stops, and the human instinct embedded in the DNA takes over. Beyond this point, this soldier will stop doing what he is trained for, but instead, will be possessed by how his own raw nerve will dictate his fight or flight response.

The simple, village-bred jawans of the Charlie Company might not have had any experience in high-altitude warfare, but they were true fighters who were meant to take the last man, last bullet stand.

The real tragedy that befell the brave jawans of the Charlie Company was when the accounts of the handful who survived were not accepted by the officers. The final orders of Maj. Shaitan Singh were received with a lot of circumspection and were rejected.

Sep. Ram Chander says that when he insisted to the officers that what he and the others were saying was the truth and the Charlie Company had indeed fought a brave battle, he was asked to shut up or face a court martial for being a liar. It was ironic that the officers who had trained the jawans to fight were not prepared to listen to the truth about the result of their own training.

Consequently, the last stand of the Charlie Company was forgotten by the army and the nation. But the gods had other plans. Because what was to follow three months later would silence even the harshest of critics within the army, and any armchair security expert elsewhere.

Rezang La, First Week of February 1963

In the first week of February 1963, a Ladakhi shepherd happened to visit Rezang La. The temperature was still fluctuating between minus 10 and minus 20 degrees Celsius and it was too early for the predators to start hunting for food. The entire moonscape of Rezang La was as white and as frigid as it was on the morning of the battle on 18 November 1962.

This shepherd was the first Indian to witness the closing stages of the battle turned into a frozen tableau. Right in front of his eyes were the frozen bodies of the Indian jawans still standing in their trenches with their weapons pointed towards the east.

He quickly informed the Indian Army unit at Chushul. The information reached the headquarters in Delhi in no time and a search party was organized. Several officers and jawans of the Indian Army, including Brig. T.N. Raina, and Red Cross representatives were part of this search party that trekked to

Rezang La from the base of Rezang La Pass, where once the Charlie Company's administrative base was located.

One of the members of this search party was Capt. Kishori Lal. In an essay published in *The Gods of Valour*, he records his first impressions on arrival at Rezang La as follows:

'We reached Rezang La on 10 February 1963. There we saw the brave sons of mother Bharat sleeping in eternal sleep. We saw there was a heavy bombardment that the Chinese had done to wipe them out. There were deep pits all around. We picked up blind bombs and weighed them. Most of them were over 80 pounds. Each body of our valiant soldiers there had over thirty–thirty-five bullet wounds. As many as forty-seven bullets had sunk into Jemadar (Naib Subedar) Hari Ram's body. On one bunker shield, we counted 759 bullet holes.'

The following excerpt from the official account of the Kumaon Regiment of the Indian Army provides more details:

'No bunker in Rezang La was found intact, corrugated iron sheets were found in bits, the *ballies* (wooden poles/logs used for making temporary shelters) had been reduced to matchwood sticks, and the sandbags were just shreds. But there was no sign of panic or withdrawal. Every single jawan was found dead in his trench; each had several bullets or splinter wounds, still holding their weapons; broken light machine guns/rifles bore witness to the intensity of the enemy fire. Jemadar (Naib Subedar) Hari Ram was found with a bandage on his head. He had apparently tied it in a hurry while rushing from one of his sections to another and was killed there: the body, when received, was still in crouching position.'

The rescuers who visited Rezang La on 10 February 1963 were speechless.

Brig. T.N. Raina called his subordinate from the search party and said, 'I want everything to be photographed. After that, make a list of the martyred jawans you can identify.'

'Yes, sir.'

'We will cremate these *bahadur* jawans today itself.'

'Sir, here?'

'Yes, right here. This land belongs to us because of these brave patriots. And there should be a memorial here for every Indian to visit and pay his respects.'

'Yes, sir.'

That evening, the bodies of ninety-six soldiers of the Charlie Company were recovered from Rezang La and they were cremated with full military honours amid the chanting of Vedic mantras. Brig. T.N. Raina lit the combined funeral pyre of the soldiers with his own hands.

Those present recall that everyone had tears in their eyes. Brig. T.N. Raina, who would later rise to become the chief of army staff, got so emotional that he had to remove his prosthetic eye for relief.

The army had initially refused to accept the account of the survivors, who were merely following the last order of their commander, Maj. Shaitan Singh. But mother nature had preserved the last stand of the brave soldiers as it is. There were no more doubts in the mind of the senior officers now. There were no more threats about court martials. They had seen it for themselves and realized that every word that the survivors had spoken was true.

Maj. Shaitan Singh's body was found at the same spot where his loyal soldiers had left him. He was still resting against the boulder, his entire body except his face covered in snow. It seemed as if the brave officer, outstanding tactician and admired

leader, was taking a bit of rest before getting up and thundering with his command to destroy the Chinese.

Maj. Shaitan Singh's body was sent to Jodhpur in a special Indian Air Force aircraft on the very next day. The CO, Lt Col H.S. Dhingra, accompanied the body and the gallant company commander was cremated with full state honours.

While Maj. Shaitan Singh was awarded the Param Vir Chakra (PVC), the highest military decoration, Brig. T.N. Raina was awarded the Maha Vir Chakra (MVC), the second highest military decoration. Lt Col H.S. Dhingra was later awarded with Ati Vishisht Seva Medal (AVSM).

All the three platoon commanders, Naib Subedar Hari Ram, Naib Subedar Surja Ram and Naib Subedar Ram Chander, were awarded Vir Chakras (VCs). Nk Ram Kumar, the section commander of the 3-inch mortar post, Nk Gulab Singh and L/Nk Singh Ram of platoon 7, and Nk Hukum Chand and Sep. Dharampal Dahiya (nursing assistant) of platoon 8 were awarded Vir Chakras too. In addition, CHM Harphul Singh, Hav. Jai Narain, Hav. Phul Singh and Sep. Nihal Singh were awarded the Sena medals. Naib Subedar Jai Narain's name was Mentioned-in-Dispatches (M-in-D).

It will never be possible to recreate an exact account of this epic battle to remember and honour other brave jawans, but one thing that the nation will always do is to bow down their heads in respect and reverence at the war memorial at Chushul called 'The Rezang La War Memorial—Ahir Dham'.

The words inscribed on this memorial were personally chosen by Lt Col H.S. Dhingra, the battalion commander of 13 Kumaon.

These are from Lord Macaulay's book of poems called *Lays of Ancient Rome* and they read:

'And how can man die better
Than facing fearful odds,
From the ashes of his fathers,
And the temples of the gods.'

13 Kumaon Battalion was awarded the battle honour Rezang La and theatre honour Ladakh. Today, 13 Kumaon's Charlie Company is officially called the Rezang La Company.

China attacked India on 20 October 1962. Six office bearers, who were holding the top positions of decision-making in New Delhi, were not present at their offices in the final few months before the attack. Who are these and where were they? Let's start from the top. Prime Minister Jawaharlal Nehru left New Delhi on 8 September 1962 to attend the Commonwealth Prime Ministers' Conference and returned on 2 October 1962, but once again departed on 12 October 1962 for Colombo from where he returned only on 16 October 1962, i.e., just four days before the war. The defence minister, Krishna Menon, was in New York from 17 September 1962 to 30 September 1962 to attend the UN General Assembly meeting. Lt Gen. B.M. Kaul, the Chief of General Staff, was on holiday in Kashmir till 2 October 1962, and the Director of Military Operations (DMO), Brig. D.K. Palit, was away on a cruise on the naval aircraft carrier *Vikrant*. This underlines the government's apathy towards nation's security resulting from a complete intelligence failure. Then there were interpersonal issues. Like, Jawaharlal Nehru didn't trust Krishna Menon when it came to China due to the latter's leftist leanings and therefore, the

prime minister had ordered certain matters to be brought up directly to him. Lt Gen. B.M. Kaul and Krishna Menon were not on talking terms as explained by Brig. D.K. Palit in his memoirs. Gen. P.N. Thapar was in awe of Lt Gen. B.M. Kaul due to the latter's proximity to Jawaharlal Nehru, who was also related to Gen. Kaul. These interpersonal issues further compounded the organizational structure at the top. Therefore, on ground, the only thing that the army had in 1962 was the raw courage and a will to lay down their lives to protect the nation. On the flip side, however, had China not attacked India in 1962, the top political masters would have never woken up and their continued indifference and mutual mistrust would have cost us a lot more in the subsequent wars.

Epilogue

In the month of December 2020, my brother and I drove to a village called Manethi in Rewari district of Haryana. Satpal Khola, the son-in-law of Sep. Mohinder Singh and my cousin's maternal uncle, was also with us. It was afternoon and the sun was bright. Our plan was to visit the house of Nk Gulab Singh, Vir Chakra, and we had to just ask one person for directions. Clearly, everyone in the village knew where the house of the *shaheed* of 1962 was located.

When we reached the house, we noticed an old woman sitting on the steps that led to the house. I walked up to her and said, '*Ram Ram*, is this Nk Gulab Singh's house?'

The old woman looked up at me and my brother, a bit puzzled for a second, and then she began to wail loudly. While we stood there, slightly confused, from inside the house, a middle-aged man emerged and escorted her in. Then he came out again and invited us inside. In the modest living room of the small house as we sat, he looked at us questioningly.

After I told him the purpose of my visit, he relaxed a bit. Then I asked him, 'Who was that old woman and why did she start crying?'

Even though by now I knew what the man was going to say, I wanted to listen to him without making any guesses. This was a serious and very delicate matter, after all.

The man replied, 'She is the widow of Nk Gulab Singh . . . and my mother.'

Then he explained that she was in Ambala, pregnant with him in 1962 when his father, Nk Gulab Singh, had to leave for Baramulla and finally for Rezang La. What he added after this made me emotional and I held on to my tears with difficulty. He said, 'My mother wrote a letter to my father after I was born. But she is not sure if he got the news in time or not as she never got a reply.'

After turning down his offer for tea, I asked him if Mrs Gulab Singh would be willing to get photographed. He nodded without any expression and went inside the house to ask her. We waited silently. He came back a few minutes later with a yes.

This time when she came, we touched her feet to seek her blessings. She blessed us with long life and happiness. Immediately after that, we clicked her photograph which I have included in this book. Later, the son, whose name was Suresh Kumar and who retired after working in the Indian Air Force, took us to a memorial located a short distance away from his house. The memorial has been made by Suresh Kumar himself with assistance from the panchayat and a few village elders, he informed us.

'Who maintains this?' I asked him.

'I do it myself, sir.' He said with pride in his eyes.

We visited more villages and paid our respects at the memorials of other martyred soldiers of the Charlie Company. Although the visits were emotionally exhausting, they made us feel proud in the end.

The writing of this book has changed me and the most important change is to value our freedom more as our countrymen have paid for it with their lives.

To the brave soldiers of the Charlie Company, as they had often said, death was acceptable but defeat was not, and therefore, in the end, 110 soldiers out of 120 belonging to the company had perished, and the Chinese had to stop right there. Their war machinery was sufficiently blunted by these brave Indian jawans and the Chinese must have realized that going beyond this point was not possible. The Rezang La battle was indeed won by China, but the Indians didn't accept defeat, and the fact that China stopped right there and declared a ceasefire on the very next day, is testimony to the fact that the soldiers of the Charlie Company indeed embraced death, but not defeat.

In conclusion, there is only one thing that requires to be mentioned. What if these brave soldiers had better guns, more ammunition, adequate snow clothing, full-stomach food, artillery support and able leaders at the army headquarters and in the government? I hope you agree with me that the answer to this question is obvious.

If you ever visit the war memorial in Chushul and if you try hard enough, you can still hear the battle cries echoing in the mountains. I hope the readers of this book will visit the memorial soon.

Glossary

Adjutant: A military officer who disseminates and coordinates the CO's operational/administrative orders to the battalion.

Advance party: A body of troops sent out in advance to a location before the arrival of the main body.

Batman: Now called buddy in the Indian Army, a batman is a soldier who assists an officer with the preparation of his uniforms, conveying messages and, if required, any other role, like driving the officer's vehicle, acting as the officer's bodyguard and other miscellaneous work as the officer orders him to do.

Battalion: In the Indian Army, a battalion is a military unit that consists of approximately 800 jawans and is commanded by an officer of the rank of Lieutenant Colonel (now a Colonel commands a battalion). It has three or four companies under it, each comprising 100 to 150 jawans commanded by a Captain/Major.

Class 9 road: A road that is six feet in width and suitable for three-tonne vehicles.

Coat parka: A type of a well-insulated coat that defies strong winds and cold and always has a hood that is faux fur-lined.

Company Havildar Major (CHM): The NCO in charge of a company, his charter of duties covers all operational and administrative

roles including the discipline of the company. The CHM closely monitors the talks of the troops and keeps an eye on them.

Concertina coil: A fusion of barbed and razor wires that is commonly used as fencing to mark a security perimeter, concertina coil can cause serious injury to animals or humans who try to cross it.

Company Quarter Master Havildar (CQMH): The CQMH is a senior NCO under whose charge are the company's logistics, administration, weapons, ammunition, etc.

Dada Kishan ki jai (**Victory to Lord Krishna**): A battle cry or a war cry is aimed at invoking patriotic, religious or community sentiment to arouse aggression and esprit de corps. *Dada Kishan ki jai* is one of the three official battle cries of the Ahirs in the Kumaon Regiment. The other official battle cries of the Kumaon Regiment are, '*Kalika mata ki jai*' (Victory to Goddess Kali) and '*Bajrang bali ki jai*' (Victory to Lord Hanuman).

Division: An Indian Army division is headed by a General Officer Commanding (GOC) holding the rank of Major General. It usually consists of 15,000 combat troops and 8000 support elements and can have three or more brigades under its command.

Dropping Zone (DZ): A designated area on land where military supplies are dropped from the air for troops on the ground.

Extreme high altitude: In the army, the areas have been divided broadly into three based on altitude: plains, high altitude (9000 feet to 15,000 feet) and extreme high altitude (above 15,000 feet). The ration scales entitled for each soldier are different for these areas.

First line of ammunition (Rifle): 100 rounds of ammunition that is carried by a jawan to be used for his issued personal weapon.

Forward policy: In the years preceding the 1962 Sino–India war, the government of India had established a string of around sixty forward posts all along the Sino–Indian border in territories that both India and China considered their own. This was called the forward policy. Spearheaded by Prime Minister Jawaharlal Nehru at the time, it was the result of the Intelligence Bureau's (IB)

and the army headquarters' intelligence appreciation that China would not attack India.

FSMO Scale A or *bada pitthu*: Field Service Marching Order (Pack 08/Scale A) is a large haversack which rests on the back of a soldier. It has a standard list of items including a small haversack, blanket, field dressing, rain cap, water bottle, mess tin, extra combat dress, etc. and weighs around 20 kg depending on the total number of items being carried which are often mission-specific. Two pouches in front are hooked to the belt and are meant to store grenades and ammunition.

Gondh ke laddu: Popular in Haryana, these high-calorie laddus are prepared by mixing gondh (dried natural gum usually derived from acacia trees), desi ghee (clarified butter) roasted flour, sugar and dry fruits. Considered particularly good during winters, these sweet snacks are consumed to improve strength and immunity.

Infantry Brigade: In the Indian Army, an Infantry Brigade is commanded by a Brigadier and consists of three Infantry Battalions along with supporting arms and services, namely, armoured squadron/troops, engineers company, artillery battery, signal company and EME workshop.

Jemadar: A Junior Commissioned Officer (JCO) rank which was used in the Indian Army until 1965. Its present-day equivalent rank is Naib Subedar. For easy reference, the rank of Jemadar in this book has been replaced at all places with Naib Subedar.

Knoll: A small rounded hill, or a mound of earth, or hillock.

Langar: Langar is a common term used across various units in the Indian Army when referring to a cookhouse for troops, sometimes even when there is no building and the food is served in the open air in the area adjacent to where it is cooked.

Line-tod: An army command which means the assembled soldiers can now break their ordered formation and leave.

Magneto telephone: A hand-cranked telephone that uses permanent magnets to produce alternating current from a rotating armature which causes the telephones on the same line to ring.

Mortar: A mortar is a lightweight and portable weapon that consists of a smooth/rifled metal tube fixed to a base plate (to spread out the recoil) with a lightweight bipod mount and a sight for direction and ranging. Mortars launch explosive shells (bombs) in high-arching ballistic trajectories and are typically used as indirect fire weapons for close fire support. The bombs are directly loaded from the top of the tube.

NCO (Non-Commissioned Officer): The Indian Army ranks from Lance Naik to Havildar are collectively called NCO.

NEFA (North East Frontier Agency): The former name of the Indian state of Arunachal Pradesh.

'O' group: In the context of a battalion, O group stands for Order group and typically comprises the Commanding Officer, all Company Commanders, Adjutant, Intelligence Officer, Battalion Quarter Master, Subedar Major, etc.

Pioneers: Personnel belonging to the Indian Army Pioneer Corps (now disbanded), a logistics branch of the Indian Army. Their main task was to support forward combat formations by building roads, mule tracks, airstrips, construction and digging work, besides bringing the injured from the battleground, assisting field hospitals, loading and unloading stores, rations and ammunition.

PLA: Founded on 1 August 1927, the People's Liberation Army or just PLA, is the world's largest military force that belongs to the People's Republic of China. It has five branches: Ground Force, Air Force, Navy, Rocket Force and Strategic Support Force.

Platoon: A platoon is an army unit that operates under a company and comprises around fifty personnel. In the Indian Army, there are three platoons under a company, each commanded by a JCO.

Quartermaster: An officer of the rank of Captain or Major under whose charge are the logistic stores and ammunition of a unit.

Re-entrant: A re-entrant is a terrain feature that appears on the map as a U or V shape in the contour lines, pointing back into a hillside rather than sticking out of the hill (as would a spur). A re-entrant,

therefore, is a small valley, the centre of which would collect water and funnel it downhill when it rained or when snow melted.

Sangar: Temporary fortification of ground positions using stones, sandbags or similar local resources. It serves as a protected position for observation or firing at the enemy.

Section: A section is the smallest subunit of the Indian Army which can fight an independent battle. There are three sections in a platoon and it comprises around ten personnel. The seniormost in a section is called a Section Commander who is usually an NCO.

Shakkar paras: Sweet dough of refined wheat flour that has been cut into rectangles around 2–3 inches in length, an inch in width and a quarter of an inch in thickness, and deep-fried. This high-energy snack can last for a couple of weeks in almost any weather conditions.

Siting: Siting is the tactical emplacement of a weapon, so as to best defend a position. It generally covers the exact location of the weapon, arcs of fire, and left and right limits of arcs of fire. Weapons are usually sited in conjunction with other weapons in the vicinity in order to have overlapping arcs of fire and also to avoid any dead zone.

Sitrep: Situation reports or sitreps are periodic reports between military formations usually along the chain of hierarchy from lower to higher that follows a predetermined time and format.

Snow goggles: A pair of tight-fitting eyeglasses worn to protect the eyes from hazards such as wind, intense sunlight, UV rays and cold, in order to protect the eyes from snow blindness.

Spit-locking: It's the army's way of marking boundaries on the ground using stones or pebbles before the actual digging or construction action takes place. This is done to orient the soldiers about the likely positions of trenches, bunkers, etc.

Spur: A spur is a lateral ridge or a piece of high ground which sticks out from the side of a hill or mountain.

Tree line: An altitude above which no trees can grow due to extreme cold and lack of moisture in the air.

Trigger guard: The loop that surrounds the trigger of a firearm and protects it from accidental pressing or activation.

Very pistol: A large-bore handgun that is also called a 'signal pistol' or 'flare gun'. It is used to fire illuminating flares that act as a warning, distress or success signal.

Watershed: An area or ridge of land that separates waters flowing to different rivers, basins or seas. In mountainous regions, it is a prominent ridgeline (line connecting the highest points of a mountain range) which is considered a natural boundary between two nations.

Bibliography

Himalayan Blunder by Brig. J.P. Dalvi.

India's China War by Neville Maxwell.

Henderson Brooks' report (part 1): Complete report yet to be declassified by Govt. of India.

1962: The War That Wasn't by Shiv Kunal Verma.

Dr P.B. Sinha and Col A.A. Athale. 'Official History of 1962 India–China War', Ed. S.N. Prasad, Govt. of India publication (March 1993), https://www.bharat-rakshak.com/ARMY/history/1962war/266-official-history.html

Valour Triumphs: A History of Kumaon Regiment by Maj. K.C. Praval.

Unsung Heroes of 1962 by Lt Col Gurdip Singh Kler, Lancer Publishers, 1995.

Official War Diary, 13 Kumaon Battalion, Indian Army.

Saini, Ravinder, and Shiv Kumar Sharma. 'Rezang La War Martyrs Remembered'. The *Tribune* (16 November 2020), https://www.tribuneindia.com/news/haryana/rezang-la-war-martyrs-remembered-170895

M.P. Anil Kumar. 'Rezang La Stands Out'. *Indian Defence Review* (8 July 2018), http://www.indiandefencereview.com/spotlights/rezang-la-stands-out/2/

Col H.S. Dhingra's (Retd) address at Rezang La memorial inauguration—29 December 2012, https://www.youtube.com/watch?v=ytM_DgS8aF8

Kashmir: The Case for Freedom by Tariq Ali, Hilal Bhatt, Angana P. Chatterji, Habbah Khatun, Pankaj Mishra and Arundhati Roy, https://books.google.co.in/books?id=2s_V4_pNhgMC&pg=PA33&redir_esc=y#v=onepage&q&f=false

Dutta, Sweta. 'Our Families Refused to Believe We Were Lucky'. The *Indian Express* (19 November 2012), http://archive.indianexpress.com/news/-our-families-refused-to-believe-we-were-lucky-/1033012/

Rao, I. Ramamohan. 'Remembering the Battle of Rezang La'. *Business Standard* (22 November 2016), https://www.business-standard.com/article/news-ani/remembering-the-battle-of-rezang-la-116112200132_1.html

List of Regiments of the Indian Army (with official war cries) https://en.wikipedia.org/wiki/List_of_regiments_of_the_Indian_Army

Maj. Gen. Raj Mehta, AVSM, VSM (Retd). 'Thermopylae Redux in High Himalaya', http://reportmysignalpm.blogspot.com/2012/10/v-behaviorurldefaultvmlo.html

Air Chief Marshal P.C. Lal. '1962 War: The Role of the IAF'. *Indian Defence Review* (17 February 2021), http://www.indiandefencereview.com/interviews/1962-war-the-role-of-the-iaf/

1962, Sino–Indian Conflict by Mrinal Talukdar (translated by Deepika Phukan).

India's Wars: A Military History, 1947–1971 by Arjun Subramaniam.

The Gods of Valour by Satya Prakash Singh.

'The Battle of Rezang La' (chapter from the book *Lest We Forget*): A blow-by-blow account of the bloodiest battle in the Indian military history by Captain Amarinder Singh.

Guruswamy, Mohan. 'We Must Never Forget Rezang La'. *The Hindu* (18 October 2016), https://www.thehindu.com/opinion/

lead/Don%E2%80%99t-forget-the-heroes-of-Rezang-La/
 article12513562.ece

'Home They Brought Their Warriors Dead' (chapter): *A Witness Account
 of the Last Scene of the Battle of Rezang La* by Capt. Kishori Lal.

Citations of the War Heroes, Govt. of India.

On Rezang La, The *Times of India*, 1962.

On Rezang La, The *Indian Express*, 27 September 1963.

Hyderabad regiment article by Mohan Guruswamy, *The Hindu*.

*The Saga of Ladakh: Heroic Battles of Rezang La and Gurung Hill,
 1961–62* by Maj. Gen. Jagjit Singh, 1983.

Valour Triumphs: The Saga of Rezang La by Virendra Verma, 1991.

Major Defence Operations Since 1947 by Gp Capt. Ranbir Singh, 2005.

The State at War in South Asia by Pradeep Barua.

Reminiscing Rezang La (coffee table book) by Col N.N. Bhatia, Vij
 Books, 2019.

The Brave: Param Vir Stories by Rachna Bisht, 2014.

Fire Under The Snow by Gyatso Palden (Tibetan monk who was
 released after thirty-three years in a Chinese jail).

China's India War by Bertil Lintner.

War in High Himalaya by Maj. Gen. D.K. Palit.

My Years with Nehru by B.N. Mullik (IB Director).

Slender Was the Thread (On Kashmir) by Lt Gen. Bogey Sen.

Subramanian, L.N. 'The Battle of Chushul'. *Bharat Rakshak Monitor*,
 Volume 3(3), (November–December 2000), https://web.archive.
 org/web/20070202180526/http://www.bharat-rakshak.com/
 MONITOR/ISSUE3-3/lns.html

Major General S.V. Thapliyal, SM (Retd). 'Battle of Eastern Ladakh:
 1962, Sino–Indian Conflict' (April 2005–June 2005), https://
 usiofindia.org/publication/usi-journal/battle-of-eastern-ladakh-
 1962-sino-indian-conflict-2/

Lamb, Alistair. 'China India Border: The Origin of the Disputed
 Boundaries', Chatham house essay, published by OUP in
 1964. https://pahar.in/mountains/Books%20and%20Articles/
 Indian%20Subcontinent/1964%20The%20China-India%20

Border--the%20origins%20of%20disputed%20boundaries%20 by%20Lamb%20s.pdf

India–China Boundary Problem 1846–1947: History and Diplomacy by A.G. Noorani.

The Fall of Tawang by Maj. Gen. Niranjan Prasad.

Rao Tula Ram by K.C. Yadav (National Book Trust, India).

Indian Army after Independence by Maj. K.C. Praval.

History of the Conflict with China, 1962 (MoD publication) by Dr P.B. Sinha and Col A.A. Athale. Edited by Dr S.N. Prasad.

Understanding the Sino–Indian War, 1962 by Gautam Das.

Telephone interview with Brig. Raghunath V. Jatar (Retd), CO of D Company in the 1962 war.

Personal interview with Honorary Capt. Ram Chander (Retd) of C Company (platoon commander of platoon 9).

Personal interview with Honorary Capt. Ram Chander (Retd) of C Company (radio operator as Sepoy in 1962).

Personal interview with Havildar Nihal Singh (Retd) of C Company (LMG det in company headquarters during Rezang La battle).

Personal interview with the CO of 13 Kumaon Battalion, Col Amit Malik.

Telephone interview with Shri. Narpat Singh, Late Maj. Shaitan Singh PVC's son.

Personal interview with Hav. Gaje Singh (Sepoy with platoon 9 during the Rezang La battle).

A Chequered Brilliance: The Many Lives of V.K. Krishna Menon by Jairam Ramesh.

The Sino–Indian War of 1962: New Perspectives by Amit R. Das Gupta and Lorenz M. Luthi.

China's India War, 1962: Looking Back to See the Future by Air Commodore Jasjit Singh (Retd).

1962 and the McMahon Line Saga by Claude Arpi.

The Fate of Tibet: When Big Insects Eat Small Insects by Claude Arpi.

JFK's Forgotten Crisis: Tibet, the CIA, and the Sino–Indian War by Bruce Riedel.

Dutta, Prabhash K. 'This Day in 1962: China–India War Started with Synchronized Attack on Ladakh, Arunachal'. *India Today* (20 October 2017), https://www.indiatoday.in/india/story/india-china-war-1962-20-october-aksai-chin-nefa-arunchal-pradesh-1067703-2017-10-20

Sino–Indian War, 1962, *Encyclopedia Britannica*, https://www.britannica.com/topic/Sino-Indian-War

Roche, Elizabeth. 'Report on India's Defeat in 1962 War Revealed'. Livemint (19 March 2014), https://www.livemint.com/Politics/VnlRYckt2cIqfnzA2jiviP/Forward-Policy-of-Jawaharlal-Nehru-govt-blamed-for-1962-deba.html

Doctor, Vikram. '1962 India–China War: Why India Needed that Jolt'. The *Economic Times* (7 October 2012), https://economictimes.indiatimes.com/news/politics-and-nation/1962-india-china-war-why-india-needed-that-jolt/articleshow/16703076.cms?utm_source=contentofinterest&utm_medium=text&utm_campaign=cppst

Maxwell, Neville. 'This is India's China War'. *South China Morning Post* (15 July 2017), https://www.scmp.com/week-asia/geopolitics/article/2102555/indias-china-war-round-two

Malhotra, Hansa. '1962 India–China War: Seven Things You Might Not Know'. The Quint, (21 November 2020), https://www.thequint.com/news/india/facts-about-1962-india-china-war

Col N.N. Bhatia (Retd). '1962 India China War, Unforgettable Battle of 1962: 13 Kumaon at Rezang La'. *Bharat Rakshak* (1 November 2012), http://www.bharat-rakshak.com/ARMY/history/1962war/414-rezang-la.html

Maj. Gen. Sheru Thapliyal. '1962 War: A Critical Analysis'. *Indian Defence Review* (30 March 2018), http://www.indiandefencereview.com/spotlights/1962-war-a-critical-analysis/

Commodore Uday Bhaskar (Retd). 'Strangely Forgotten: On Rezang La'. *The Hindu* (16 November 2017), https://www.thehindu.com/opinion/op-ed/strangely-forgotten/article20461145.ece

Gupta, Shekhar. 'Remembering the Battle of Rezang La through the Eyes of Two Brave Soldiers'. ThePrint (18 November 2018), https://theprint.in/walk-the-talk/56-years-on-remembering-the-battle-of-rezang-la-through-the-eyes-of-two-brave-soldiers/150549/

'Army Observes 54th Anniversary of Battle of Rezang La in Ladakh'. *Pune Mirror* (19 November 2019), https://punemirror.indiatimes.com/news/india/army-observes-54th-anniversary-of-battle-of-rezang-la-in-ladakh/articleshow/72128779.cms

Col. Dilbag Dabas. 'Heroes of 1962 Rezang La Battle'. The *Tribune* (15 December 2018), https://www.tribuneindia.com/news/archive/haryanatribune/heroes-of-1962-rezang-la-battle-698535

Gupta, Shekhar. 'Nobody Believed We Had Killed So Many Chinese at Rezang La. Our Commander Called Me Crazy and Warned That I Could Be Court-Martialled'. The *Indian Express* (30 October 2012), http://archive.indianexpress.com/news/-nobody-believed-we-had-killed-so-many-chinese-at-rezang-la.-our-commander-called-me-crazy-and-warned-that-i-could-be-courtmartialled-/1023745/

'India–China War in Rezang La: When 124 Indian Soldiers Fought 1000 Chinese Troops in 1962'. *BBC Hindi* (11 March 2019), https://www.youtube.com/watch?v=quWUicBpkwI

'Maj. Shaitan Singh: Man Who Taught Chinese a Lesson in the Battle of Rezang La'. *India Today* video (6 October 2018), https://www.indiatoday.in/programme/param-vir-chakra/video/Maj.or-shaitan-singh-man-who-taught-chinese-a-lesson-in-the-battle-of-rezang-la-1357566-2018-10-06

'DNA: Analysing the Unforgettable India–China War of 1962'. *ZEE News* video (19 November 2016), https://www.youtube.com/watch?v=79-wYad_j9A

'Vande Mataram, Story of Major Shaitan Singh'. *Aaj Tak* video (4 September 2016), https://www.youtube.com/watch?v=vmywNzXu34M

'The Great Escape—Episode 4—Rezang La'. *The EPIC Channel* (1 August 2016), https://www.youtube.com/watch?v=pcM_JbxUJRo

'Sentinels of the Snow'. *The EPIC Channel* (16 December 2018), https://www.youtube.com/watch?v=IPl-bOp2bPk

'1962 War Legend: How 123 Indian Jawans Defeated 1300 Chinese Troopers'. *News Nation* (2 December 2019), https://www.youtube.com/watch?v=SioCdlHq7xI

Garver, John W. 'China's Decision for War with India in 1962', https://www.chinacenter.net/wp-content/uploads/2016/04/china-decision-for-war-with-india-1962.pdf

Tharoor, Ishaan. 'The Sino–Indian War: 50 Years Later, Will India and China Clash Again?' *TIME* (21 October 2012), https://world.time.com/2012/10/21/the-sino-indian-war-50-years-later-will-india-and-china-clash-again/

'India: Never Again the Same'. *TIME* magazine cover story, (30 November 1962), http://content.time.com/time/magazine/article/0,9171,829540,00.html

'The Sino Indian Border Dispute'. Declassified CIA files in May 2007, Section 2 (1959–61) accessed on 9 April 2020, https://www.cia.gov/readingroom/document/cia-rdp79r00904a000800020012-1

The Guilty Men of 1962 by D.R. Mankekar.

Wg Cdr Hoshang K Patel. 'Independence and the China War', Bharatrakshak.com (Chinese checkers forum).

Rivers of Silence by Ashok Kalyan Verma.

India's Wars Since Independence by Maj. Gen. Sukhwant Singh.

Abitbol, Aldo D. 'Causes of the 1962 Sino–Indian War'. University of Denver (Summer 2009), https://digitalcommons.du.edu/cgi/viewcontent.cgi?article=1000&context=advancedintlstudies

Gp Capt. A.G. Bewoor VM (Retd). 'Close Air Support in the 1962 War'. *Bharat Rakshak* (12 June 2017), http://www.bharat-rakshak.com/IAF/history/1962war/1019-bewoor.html

Calvin, James Barnard, Lieutenant Commander, US Navy. 'The China–India Border War (1962)'. *GlobalSecurity.org* (April 1984),

https://www.globalsecurity.org/military/library/report/1984/CJB.htm#

Chellaney, Brahma. 'A War China Won only to Lose'. Livemint (17 October 2012), https://www.livemint.com/Opinion/fINQNMSls85qPWbI0WjSDL/A-war-China-won-only-to-lose.html

'The Chinese People's Liberation Army at 75'. Eds. Burkitt, Laurie, Andrew Scobell and Larry M. Wortzel. https://web.stanford.edu/group/tomzgroup/pmwiki/uploads/0199-2003-Burkitt-a-IEM.pdf

Fisher, Margaret W.; Rose, Leo E. and Huttenback, Robert A. 'Himalayan Battleground: Sino–Indian Rivalry in Ladakh'. https://www.questia.com/read/10466588/himalayan-battleground-sino-indian-rivalry-in-ladakh

Arpi, Claude. 'Remembering a War'. *Rediff.com* (15 November 2002), http://ia.rediff.com/news/2002/nov/15chin.htm

Vembu, Venkatesan. 'China, India and the Fruits of Nehru's Folly'. *DNA* (6 June 2007), https://www.dnaindia.com/world/report-china-india-and-the-fruits-of-nehru-s-folly-1101845

Khatri, Sunil. 'Events Leading to the Sino–Indian Conflict of 1962'. *IDSA Monograph Series*, No. 58 (February 2017), https://idsa.in/system/files/monograph/monograph58.pdf

'1962: A View from the Other Side of the Hill'. Eds. P.J.S. Sandhu, Bhavna Tripathi, Ranjit Singh Kalha, Bharat Kumar, G.G. Dwivedi, Vinay Shankar. VIJ Books, 2015.

Red Fear: The China Threat by Iqbal Chand Malhotra, (Bloomsbury India).

Butalia, Nivriti. 'The Ghost of 1962 and Other Stories'. *Hindustan Times* (19 December 2010), https://www.hindustantimes.com/delhi/the-ghost-of-1962-and-other-stories/story-uUwi56C5wLUWrPfJ1A2NRO.html

Acknowledgements

There are a lot of people I need to thank, but I would like to begin by thanking the families of the war heroes whom I visited in the villages of Haryana. I thank them for their hospitality, kindness and large-heartedness as they shared the stories about their family members who had laid down their lives.

I am grateful to Col Amit Malik, CO, 13 Kumaon, for providing the photographs that I have used in this book, and for presenting the coffee table book on Rezang La written by Col N.N. Bhatia (Retd) to me. Subsequently, his staff succeeded in locating the original war diary too, which turned out to be an invaluable source of information as it was hand-written during the 1962 war. I would also like to thank the two adjutants of 13 Kumaon, Capt. Atul Kumar Yadav and Maj. Avinash Patil, in addition to Naib Subedar Jai Bhagwan, whose team had located the war diary among the old records of the battalion.

It was an honour to speak with Brig. Raghunath V. Jatar (Retd) who responded to my message from Pune saying he would be happy to interact over a video call on WhatsApp. Speaking to the octogenarian officer on video was both informative and fun.

I also spoke to Brig. Prem Kumar (Retd) who lives in Panchkula and he gave me a lot of information about October 1962, as it was him who had led a platoon of the Charlie Company to Rezang La before Maj. Shaitan Singh arrived with rest of the platoons and took over from him.

In addition to the information that I could get from Brig. Raghunath V. Jatar (Retd) and Brig. Prem Kumar (Retd), both of whom had vivid memories of Maj. Shaitan Singh (Maj. Shaitan Singh had even attended Brig. Prem Kumar's wedding in Pathankot on 24 April 1962), I also spoke with Narpat Singh, son of Maj. Shaitan Singh, who lives in Jodhpur. Furthermore, a young researcher named Jai Samota, who is writing a biography on Maj. Shaitan Singh, helped me fill in the gaps related to the information that I had gathered from books, magazines, newspapers and online resources about Maj. Shaitan Singh's formative years.

It was an honour to meet the survivors of this epic war. I met Capt. (Honorary) Ram Chander (Retd), platoon commander of platoon 9; Havildar Nihal Singh (Retd), deployed at Company headquarters with an LMG; Capt. (Honorary) Ram Chander (Retd), radio operator; and Havildar Gaje Singh (Retd), deployed at platoon 9. Just breathing the same air as these war heroes and listening to the valour of the Charlie Company filled me with immense pride and gratitude as an Indian.

I'm grateful to Mrs Suneeta Mukherjee, Lt Col H.S. Dhingra's (Retd) daughter, who invited me to her house in Gurgaon and showed me the photographs of her father and helped me understand him in flesh and blood. She also shared Lt Col H.S. Dhingra's emotional address that he had delivered on 29 December 2012 during the inauguration of the Rezang La war memorial in Gurgaon. I'm also grateful to Maj. Haramrit

Singh Dhingra (Retd), Lt Col H.S. Dhingra's son, with whom I
spoke over the phone in Chandigarh.

To find out more about Gen. T.N. Raina, who was the
Brigade Commander of the 114 Brigade stationed in Chushul
in 1962, I got in touch with his daughter, Mrs Anita Thapan.
I'm grateful to her for speaking to me twice over the phone and
passing on the number of Brig. Satish K. Issar (Retd), who was
the military assistant to Gen. T.N. Raina when he was the Chief
of the Army Staff, to get more information. Since Brig. Satish K.
Issar was writing a biography on Gen. T.N. Raina at the time,
he politely asked me to wait for the book to find out all about
the general. But I ran out of time as this book went to print
before the biography was out.

Among the researchers and historians, I would like to thank
Maj. (Dr) T.C. Rao, Dr Ishwar Singh Yadav, Prof. K.C. Yadav,
Rao Ajit Singh and Mr Naresh Chauhan of the Rezang La Samiti
for providing so many crucial pieces of information that helped
me to write this book more authentically and authoritatively.

I would like to thank Col Narender Yadav, my wife's
maternal uncle, and Col (Dr) Andy Anil, my brother, for
reading the first draft of the book and suggesting corrections.
My brother was rock solid with me all through these two years,
setting aside all his engagements to travel with me every single
time I asked him to.

I'm also grateful to Mr Satpal Khola, social activist and my
cousin's maternal uncle, who is married to the daughter of Sepoy
Mohinder Singh (radio operator) who had laid down his life in
this battle. He spent a full day with me, guiding me through the
village roads to the family members of the war heroes.

My heartfelt gratitude also goes to many others for their
support in writing this book: Wg Cdr M.A. Afraz (Retd),

Founder, Honourpoint; Col N.N. Bhatia (Retd), author, coffee-table book on Rezang La titled *Reminiscing Battle of Rezang La*; Pankaj Yadav, Indian correspondent, Xinhua news agency in Delhi; Col Chandu Lal, a retired officer of the Kumaon Regiment who was in the intelligence cell with 13 Kumaon during the 1962 battle; B.R. Deepak, professor, Jawaharlal Nehru University (JNU), New Delhi, sinologist and author; Commandant A.K.S. Panwar (Retd), a war history enthusiast; Mohan Guruswamy, Chairman, Centre for Policy Alternatives; and Ravi Yadav, director and producer in Bollywood.

I wrote most of this book at home, but certain portions were written at The Reader's Café located at Indirapuram Habitat Centre in Ghaziabad and I'm grateful to Ambuj, Anuj and the cafe's wonderful team for their kind hospitality.

This book would not have been possible without the support of Suhail Mathur, my friend and literary agent, and Milee Ashwarya, publisher at Penguin Random House India. It was only after the acceptance of Milee that I could start with the research and writing of this book and I thank her for her continued trust and support as this is my second book with Penguin. I'm also thankful to Vineet Gill and Ralph Rebello from her team for the professional manner in which they coordinated and executed the edits.

I'm also grateful to Maj. Gen. Vikram Dev Dogra, AVSM, the first serving Indian Army officer and the only general in the world to do the Ironman Triathlon event twice, who accepted my request to write a foreword for this book.

And finally, thank you, Dad and Mom for encouraging me to write this book; Seema, my wife, and Mehal and Liana, my daughters, for providing support that only a family can. Thanks are also due to my mother-in-law, Sachin, Rachna,

Liyasha, Vinita, Arnav, Reema, Sanjay, Ruhi, Rajeev, Vikas, Nisha, Amit, Vishal, Anu, Saurav, Praveen, Jitender, Nitin and all other family members and friends in India and abroad. You know who you are and each one of you has played some part, knowingly or unknowingly, in encouraging, supporting and trusting me to write this book. I'm grateful to each one of you.